The Campus History Series

MUNDELEIN SEMINARY

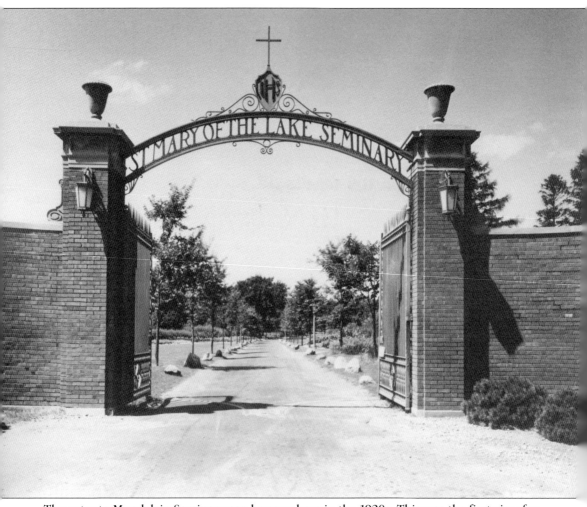

The gates to Mundelein Seminary can be seen here in the 1920s. This was the first view for the 800,000 people who came to Mundelein in 1926 for the closing ceremonies of the 28th International Eucharistic Congress. It is also the first view for the young men who come here each year to train for the priesthood. (Courtesy of University of St. Mary of the Lake.)

The Campus History Series

MUNDELEIN SEMINARY

GAIL KAHOVER

ARCADIA
PUBLISHING

Copyright © 2014 by Gail Kahover
ISBN 978-1-4671-1201-7

Published by Arcadia Publishing
Charleston, South Carolina

Printed in the United States of America

Library of Congress Catalog Card Number: 2013955316

For all general information, please contact Arcadia Publishing:
Telephone 843-853-2070
Fax 843-853-0044
E-mail sales@arcadiapublishing.com
For customer service and orders:
Toll-Free 1-888-313-2665

Visit us on the Internet at www.arcadiapublishing.com

This is dedicated to all the young men who are devoting their lives to the priesthood. God bless all of you.

CONTENTS

Acknowledgments

6

Introduction

7

1. In a Town Called Area

9

2. The First Cardinal of the West

15

3. The Construction of an American Seminary

23

4. The 28th International Eucharistic Congress

41

5. The Glory of a Vocation

59

6. Play and Pray

85

7. Brick and Stone Walls

105

ACKNOWLEDGMENTS

This book has truly been a labor of love for me, but I did not toil alone. Many people helped along the way.

I would like to thank Julie Satzik and the employees at the Archdiocese of Chicago's Joseph Cardinal Bernardin Archives and Records Center for their help with many of the photographs in this book, Arthur Miller from Lake Forest College for his help with the International Eucharistic Congress train photographs, and Jennifer Barry and the Libertyville-Mundelein Historical Society for allowing me access to the society's archives. Special thanks to Leah Munoz, Jeanna Claussen, Mark Teresi, Fr. Tom Franzman, and Fr. Robert Barron from Mundelein Seminary for their help and trust in allowing me to write a history of this wonderful institution. Thanks also to the staff of the Feehan Memorial Library, who were so gracious to me during my research. Library director Lorraine Olley has been a blessing, giving me access to the library's archives and photographs, as well as her own insight on the history of the seminary.

On a personal note, I want to acknowledge my friends who supported me with kind words and thoughts, including Robin Kollman; my Christ Reviews His Parish (CRHP) sisters from St. Joseph's Catholic Church in Libertyville; Liz Meyers, who lent me her keen editor's eye; and Theresa Ertmanis, for her unending encouragement and friendship.

I want to thank my wonderful husband, Jim, who endured my time away for research and writing. I also want to thank the Lord for the opportunity to write about this "Garden of God."

Lastly, since all the royalties from the sale of this book go to a fund for Mundelein seminarians, I thank you for your support.

The majority of the images in this volume appear courtesy of the University of St. Mary of the Lake (USML) and the Joseph Cardinal Bernardin Archives and Records Center (BARC). Other sources are credited individually.

INTRODUCTION

Mundelein Seminary has been training young men to be Catholic priests ever since its inception in 1921, when a group of 45 neophyte students first ventured through its gates.

The seminary is not only the largest priesthood preparation program in the country, it is also unique in its natural setting and beautiful campus buildings. Its Colonial style of architecture beckons a person to another place and time.

Nestled among a dense forest of trees and a vast lake, the seminary is secluded from the hustle and bustle outside its walls. The Mundelein, Illinois, location is just a stone's throw from busy thoroughfares, mega-shopping malls, and a major amusement park. Upon entering the seminary gates, one feels like they have been transported back in time.

Imagine for a moment the experience of these 18- and 19-year-old men arriving at the gates for the first time. A young man, who was among a group of 71 to enter the seminary on September 9, 1937, wrote, "We were not met by any bands. No pennants flapping in the breeze bore the word 'Welcome.' Nevertheless, each of us experienced a thrill as we gazed at the engraving over the entrance to the grounds . . . St. Mary of the Lake Seminary. Tossing our baggage onto trucks, we entered the grounds admiring the flower beds bordering the road, a scene too beautiful to be described."

The seminary was the bold vision of Chicago's third archbishop, Card. George William Mundelein. Mundelein had a dream to build not only the largest seminary in the country, he wanted to make it the best. He wanted to provide his seminarians with a first-class education in the best possible facilities and do it with a truly American flair.

Edward R. Kantowicz, who wrote about Mundelein in the book *Corporation Sole*, commented that the seminary was much more than simply a place for young men to study to be priests. "To Mundelein, it was a monument, a showcase, and the intellectual heart of the Catholic Church in Chicago," he wrote. "In his eyes and in the eyes of many contemporaries, building the major seminary on such a lavish scale, in so short a time, was his greatest achievement."

Indeed, Mundelein knew he wanted to a build a major seminary as soon as he was named archbishop of the Archdiocese of Chicago in 1915. By 1919, he began to purchase property in Area, Illinois, a small town about 40 miles northwest of Chicago. The previous owner, Arthur F. Sheldon, had operated a correspondence school for salesmen on the property.

In 1920, he announced he would build a new seminary and name it the University of St. Mary of the Lake after a Catholic institution in Chicago that closed in 1866. He hired a young architect, Joseph W. McCarthy, to design the seminary.

McCarthy designed the buildings with a Colonial style. Some of the exteriors were based on buildings steeped in American history. For example, the Cardinal's Villa is based on George

Washington's Mount Vernon home, and the main chapel looks like the First Congregational Church in Old Lyme, Connecticut. But the interiors reveal a much more Roman influence. The interior of the Feehan Memorial Library, for instance, looks more like a 17th-century Italian palace.

In recognition to Mundelein for bringing the seminary to the town of Area, the town fathers voted in December 1924 to change the name of the community to Mundelein. Thankful for the honor, Cardinal Mundelein presented the town with its first motorized fire engine in July 1925. Sen. Charles S. Deneen, a one-time Illinois governor, said during the presentation, "It is proper as time goes on that the name of the great man who planted this great institution here should always be linked with this community and this place."

Construction was completed on the majority of the main buildings on campus in time for Mundelein to welcome the world. Mundelein and the seminary hosted closing ceremonies for the 28th International Eucharistic Congress on June 24, 1926. More than 800,000 people traveled to Mundelein for ceremonies on the last day of the congress, which included a Mass and a procession around the grounds. The event not only marked the largest Mass movement of people in American history, it also put Cardinal Mundelein and the seminary on the international map.

Mundelein died in 1939 while at his villa at the seminary and is buried under the altar in the main chapel. Other archbishops followed, and the seminary continued to do what it did best: train young men for the priesthood.

The educational training has changed slowly over time. During its first 40 or so years of existence, traditional rules of Roman seminaries—as well as those implemented at military academies—were applied. Seminarians had a very strict regimen of studies and prayer, and they were not allowed to leave campus. Kantowicz, in *Corporation Sole*, called the system "a medieval education in first-class American surroundings."

As the world changed, so did the seminary. World wars, the 1960s, and the Second Vatican Council all had roles in the evolution of the seminary and the Catholic Church.

The Jesuits, who had done all the teaching, were largely gone by the 1970s and replaced by priests from within the archdiocese. Mundelein's plan of having young men go straight from the preparatory high school to college at Mundelein changed with the addition of a college seminary in Chicago, leaving Mundelein Seminary for graduate-level studies.

The young men entering the priesthood now have the freedom to leave campus. They have access to wireless Internet in all the buildings. They come to Mundelein with at least a bachelor's degree and study such subjects as theology, church history, and canon law. They can receive master's degrees and doctorates granted by the university, as well as pontifical degrees by the pontifical faculty. In addition, degree and certificate programs are available through the university's extensive programs for lay ministers and clergy.

Currently, young men from 31 dioceses from around the country and the world come to Mundelein to study to be priests. These dioceses include Atlanta; Green Bay, Wisconsin; Albany, New York; Tucson, Arizona; and Seattle, Washington. International students come from Cameroon, Uganda, and Vietnam.

Mundelein Seminary will celebrate its 100th birthday in 2021. The buildings will likely still look like Colonial America in the 1700s, and the young men inside its buildings will still be studying for the priesthood. They will be from the United States, as Cardinal Mundelein had hoped, but from many other places as well. Cardinal Mundelein's influence on this sacred place will continue to be felt.

Card. Patrick J. Hayes, archbishop of New York, may have summed up Mundelein's lasting legacy the best. In a 1934 speech to celebrate Mundelein's silver jubilee, Hayes said to his longtime friend, "You, my lord cardinal, are not parochial or diocesan. You have looked with prophetic eyes on the church in America, doing in a magnificent and monumental way all you can to spread the kingdom of Christ in our beloved land. You have glorified Christ on our altars by the seminary you have built. What a priesthood it will give to Chicago!"

One

IN A TOWN CALLED AREA

Mundelein Seminary's history is closely aligned with the beginnings of the Archdiocese of Chicago.

Chicago was a frontier town of about 18,000 people in 1844 when the Rev. William Quarter was named the diocese's first bishop. When he arrived from New York, he found a single unfinished church in Chicago and two priests. Later that year, he secured a charter for the University of St. Mary of the Lake. The school/seminary was Chicago's first institution of higher learning.

The management of the university changed hands numerous times over its 20-year history. Fr. John McMullen, an alumnus of the school, took over in 1861 and constructed a new building. But straddled with debt, the faculty was forced to close the University of St. Mary of the Lake in 1866.

By the early 1900s, the Catholic population in Chicago had exploded. In 1909, the city had 223 churches and 600 priests. Many of those churches were divided along ethnic lines. The Catholic population of the diocese, including the suburbs, was 1.2 million.

This was the setting in which George William Mundelein found himself in 1915 when he was named archbishop of Chicago. Mundelein's top priorities were to build a major and a minor seminary to train priests for archdiocesan churches. He announced plans for the Quigley Preparatory Seminary shortly after his installation. In 1920, Mundelein surprised many when he announced he would build a major seminary and call it the University of St. Mary of the Lake, forever linking Catholic Chicago's past with the present.

The seminary was to be built on nearly 1,000 acres of land in Lake County, Illinois, about 40 miles northwest of Chicago. Arthur F. Sheldon, who operated a school called the Sheldon Correspondence School of Creative Salesmanship, had owned the property.

The slogan for Sheldon's school was "Ability, Reliability, Endurance and Action," or, as it was known by its acronym, Area. Sheldon wanted the leaders of the town of Rockefeller to change the community's name. Apparently swayed by Sheldon's salesmanship, the town's name was changed to Area in 1909.

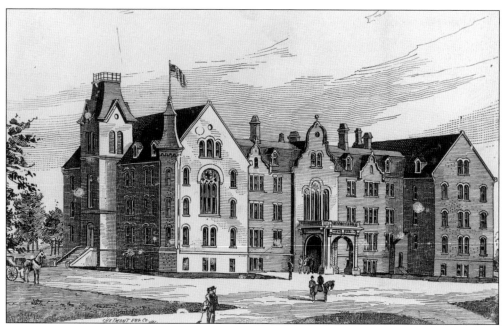

A sketch shows how the University of St. Mary of the Lake in Chicago looked in 1864. Two years later, the school would close, and the building would be used as an orphanage. Like many structures in downtown Chicago, the building was destroyed by the Chicago Fire in October 1871. (BARC.)

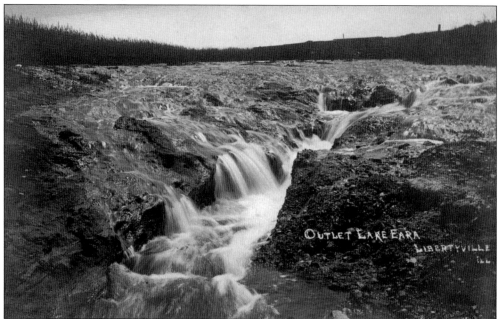

This is an early view of the land that would soon be developed by Cardinal Mundelein for Mundelein Seminary. Arthur Sheldon, who had owned the property, dammed part of an existing lake called Mud Lake. Using a variation of the acronym for "Ability, Reliability, Endurance and Action," he dubbed the body of water Lake Eara. (Libertyville-Mundelein Historical Society.)

Arthur Sheldon founded the Sheldon Correspondence School of Creative Salesmanship on the property in 1910. Primarily a correspondence school, he sold workbooks that highlighted his sales methods. He built a road around the lake and offices and eventually employed 195 people. (USML.)

Note the heavily wooded areas around the office in this view of one of the buildings on Sheldon's property. Sheldon apparently enjoyed the scenery, so he kept the woods intact. (USML.)

This is a 1910 photograph of Sheldon's press building. In his book *The Science of Successful Salesmanship*, Sheldon tells his correspondence students the school "is destined to place the commercial world in a greatly advanced position." (Libertyville-Mundelein Historical Society.)

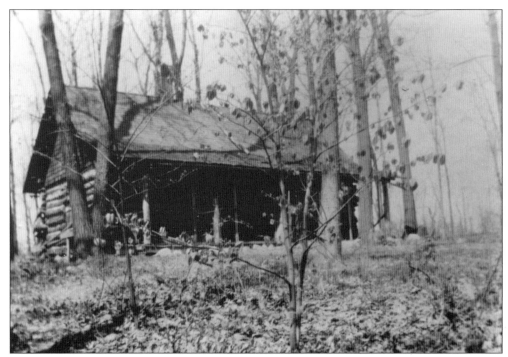

Ed Dryer, one of Sheldon's employees, built Wind Whistle Cabin in 1908. The cabin had three rooms, a large living room, and a loft that went over the kitchen. (Libertyville-Mundelein Historical Society.)

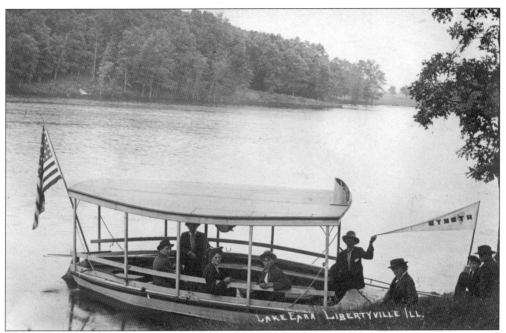

The beauty of the property surrounding Sheldon's office buildings was accentuated by the mile-long Lake Eara. Boat rides were a popular pastime on the spring-fed lake. (Libertyville-Mundelein Historical Society.)

Sheldon's property was also a good place to enjoy a picnic or just take in the scenery. In 1909, Sheldon convinced the leaders of Rockefeller to change the name of their town to Area. (Libertyville-Mundelein Historical Society.)

By 1915, Sheldon's school was in financial trouble, and the property was being sold. Fr. Daniel Luttrell, the brother of Fr. Stephen Luttrell (pastor of St. Joseph's Church in nearby Libertyville), informed archdiocesan officials that property was available up north in Area. Mundelein and two others visited the site and decided to buy 172 aces. Shortly after, they purchased property that included Sheldon's office buildings. By the time they acquired adjacent farmland two years later, the archdiocese had purchased a total of almost 1,000 acres. (Libertyville-Mundelein Historical Society.)

This is an early view of the property after it was purchased by the Archdiocese of Chicago. The photograph, dated December 5, 1923, shows the refectory (the dining hall), which was built in 1921, and the future site of the Chapel of the Immaculate Conception, which was completed in 1925. (BARC.)

Two

THE FIRST CARDINAL OF THE WEST

No history of Mundelein Seminary would be complete without recognition given to its founder and namesake, George William Mundelein.

Mundelein was larger than life, and his influence on Chicago Catholicism is unparalleled. His legacy can be seen in the 87 new parishes built during the key years of his episcopacy, between 1916 and 1934, plus 87 new parochial schools, 30 new high schools, two colleges for women, and some 40 buildings, orphanages, homes, and hospitals.

During his years as archbishop, he joined the College of Cardinals, dined with a president, and brought millions of Catholics from around the world together in Chicago during the International Eucharistic Congress in 1926.

It was quite a feat for the New York native, who was named the third archbishop of Chicago on December 9, 1915. He told a reporter from the *Chicago Daily Tribune*, "Do you know that I have never been to Chicago in my life? I never had the faintest idea this great honor would be conferred upon me by the Holy Father."

But Mundelein, the youngest archbishop in the country at the time, was adopted quickly by the faithful of Chicago. Nearly one million turned out to welcome him back home after being installed in the College of Cardinals in 1924. An estimated 750,000 lined the streets to view his funeral procession in October 1939.

Of all of his successes, Mundelein Seminary was perhaps closest to his heart. In *The First Cardinal of the West*, a 1934 book about Mundelein, the author described the seminary this way: "Cardinal Mundelein, knowing—far better than any lay person could ever know—what is needed to train the seminarian as efficiently as possible, has set these young men aside at St. Mary of the Lake, there to spend six years in the garden he has brought into being, and, truly, it is a Garden of God."

Mundelein left his mark on campus. He died at the cardinal's residence on campus and is entombed behind the altar of the Chapel of the Immaculate Conception.

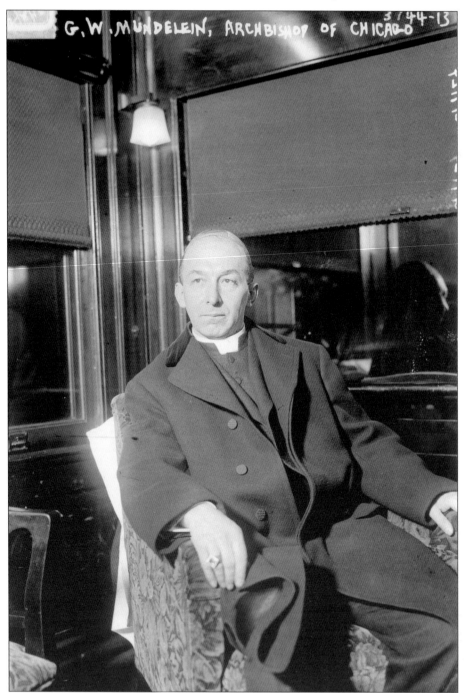

Mundelein is pictured during the train ride from his native New York to Chicago, where he would be installed as the third archbishop of Chicago on February 9, 1916. Mundelein told a *Chicago Daily Tribune* reporter in December 1915, shortly after his appointment was made, "The problems of Chicago are not unlike those of New York. I am glad that I am being sent to a great city like Chicago instead of to a smaller place, because I am familiar with people of big cities." (Fr. Tom Franzman.)

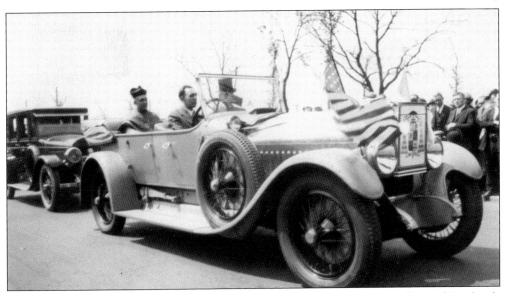

Cardinal Mundelein arrives in Area shortly after being installed in the College of Cardinals on March 24, 1924. Thousands of people showed up to greet Mundelein on his return home from Rome. He was called the "First Cardinal of the West" for being the first cardinal named in the United States west of the Allegheny Mountains. (BARC.)

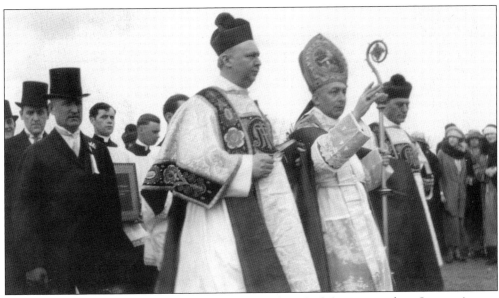

Cardinal Mundelein blesses the site of the new Chapel of the Immaculate Conception on May 24, 1924. As part of his address, Mundelein called the seminary a "workshop of God." He said, "Never since its very beginning has the diocese engaged in a task more necessary for its well-being than the work under way in this place." (BARC.)

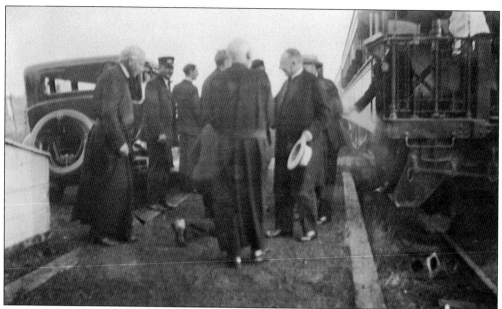

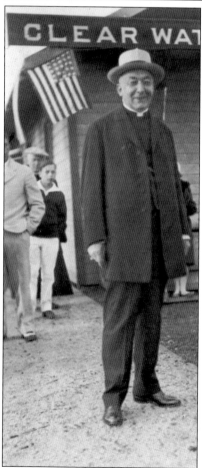

Mundelein seminarians did not go home during the summer. Some traveled north to St. Mary's Villa, a camp owned by the archdiocese in northern Wisconsin. Cardinal Mundelein visited frequently, sometimes spending a week or two at the camp. The seminarians enjoyed his visits. A seminarian wrote in the 1928 *Argus*, the camp newspaper, "No one who saw him [the Cardinal] in the frame of the door as he slowly left Clearwater will doubt that more than being a Cardinal of the church, he is a father to the seminarians." The photograph above was captured during a visit in July 1928, while the image to the left was taken in August 1929. (USML.)

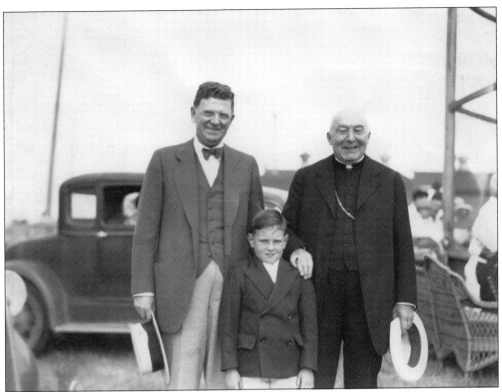

Mundelein poses with Chicago mayor Edward Kelly and an unidentified boy in the summer of 1937. Kelly, who was mayor from 1933 to 1947, stopped by the camp at least one other time on his way to his Wisconsin summer home. (USML.)

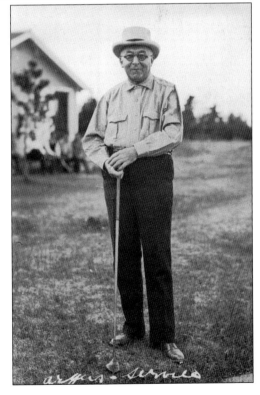

Mundelein enjoyed getting in a few rounds of golf while at St. Mary's Villa. This photograph was taken in August 1932. The cardinal also reportedly enjoyed taking walks around the property. (USML.)

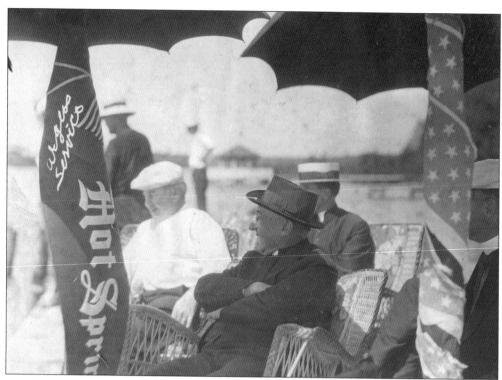

The cardinal enjoys the Wisconsin outdoors while watching a swimming competition in the August 1930 image seen above. The seminarians often expressed their appreciation to the cardinal during his visits, as seen in the scrapbook page at left from the July 26, 1934 edition of the *Argus*. (USML.)

Mundelein gives a tour of Mundelein Seminary to his guest, Card. Eugenio Pacelli, the papal secretary of state, in October 1936. Three years later, Pacelli became Pope Pius XII. This was the first visit made by a future pope to Chicago. (USML.)

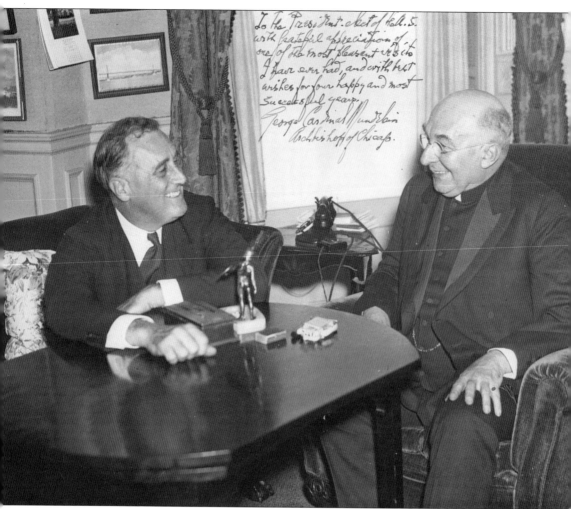

Pres. Franklin D. Roosevelt meets with Cardinal Mundelein in FDR's Albany, New York, office on November 18, 1932. Mundelein had been close friends with Roosevelt during his time in New York, and the two leaders met together many times during Roosevelt's presidency. When this photograph was taken, FDR had just been elected to his first term of office. Mundelein's handwritten note to FDR reads, "To the President-elect of the U.S., with grateful appreciation of one of the most pleasant visits I have ever had, and with best wishes for four happy and most successful years. George Cardinal Mundelein/Archbishop of Chicago." (Franklin D. Roosevelt Presidential Library and Museum.)

Three

THE CONSTRUCTION OF AN AMERICAN SEMINARY

After buying property in Area, Mundelein hired architect Joseph W. McCarthy to design his seminary. Before starting his own practice in 1911, McCarthy was an apprentice in the firm run by well-known Chicago architect Daniel Burnham.

McCarthy was Mundelein's go-to architect. Between 1916 and 1945, McCarthy had completed 28 full-scale churches in the Archdiocese of Chicago.

The new seminary buildings would be constructed in classic Colonial style (think New England in the 1700s). Mundelein wanted the seminary to represent Catholicism in a truly American form. Simply, he wanted the seminary to be the best in the world and 100 percent American.

In June 1917, Mundelein spoke at the dedication of St. Thomas of Canterbury Church in Chicago and commented on that church's "pure Colonial" style of architecture. He wrote, "Coming at this time, when our country calls for every particle of our loyalty, it is almost symbolical of the twin devotions of your heart, love of God and love of country."

Armed with seed money from a donation of fellow priests throughout the Archdiocese and a $500,000 donation from Edward Hines, president of the Hines Lumber Company in memory of his son, contracts were signed and construction began in June 1920.

The first seminarians were welcomed into new buildings in February 1922. The remaining buildings, including the chapel, library, the cardinal's residence, and the auditorium, were all completed within 12 years.

No major changes were made to the McCarthy's original layout until 2004, when the McEssy Theological Resource Center was built to provide additional library space.

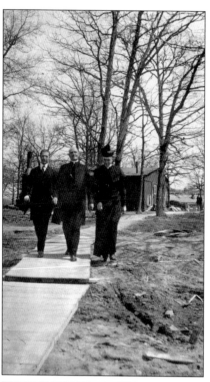

In this 1922 photograph at the seminary, architect Joseph W. McCarthy (left) walks with Archbishop Edward Hanna (center) and the Reverend J. Gerald Kealy. Kealy was the first rector of the seminary, a position he held from 1921 to 1936. Hanna served as archbishop of San Francisco from 1915 to 1935. (BARC.)

The power plant, as seen here in 1923, was one of the first buildings to be completed on campus, providing steam, electricity, and water to seminary buildings. The power plant became operational in 1921. (BARC.)

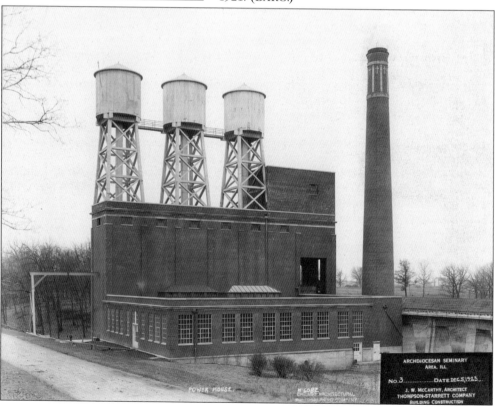

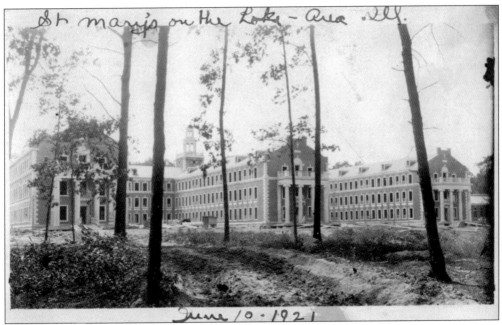

This is a 1921 postcard view of the Philosophy Residences and classroom buildings. These buildings were among the first to be constructed, along with the refectory and power plant. (USML.)

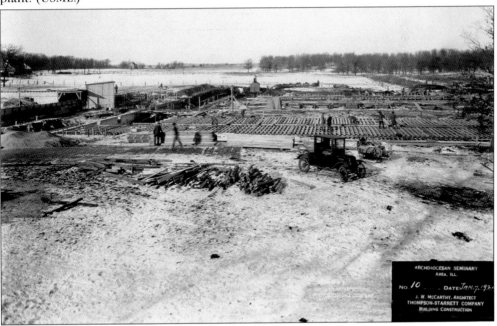

Work on the foundation of a building takes place in this early construction photograph from January 1924. Mundelein envisioned the seminary as a "Catholic University of the West," which would have included houses of study by religious orders and an affiliation with Chicago's DePaul and Loyola Universities; however, plans stalled after opposition from the Catholic University in Washington, D.C. and the unwillingness of the religious orders to relocate. (BARC.)

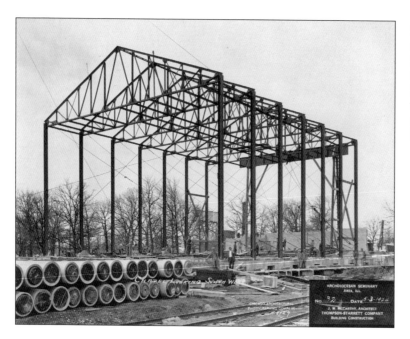

The frame of the new Chapel of the Immaculate Conception can be seen in this view looking southeast on May 3, 1924. (BARC.)

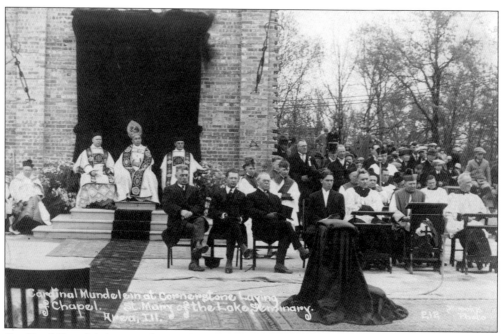

Cardinal Mundelein presides at the laying of the cornerstone for the chapel on May 25, 1924. This was considered the official dedication of the seminary, although students had been admitted for classes in October 1921. Mundelein dedicated the chapel in memory of Lt. Edward Hines Jr., who died in 1918 during World War I. (BARC.)

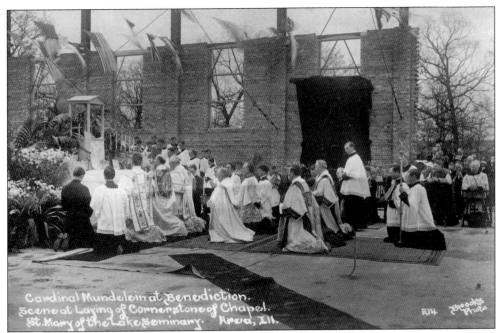

Cardinal Mundelein at Benediction. Scene at Laying of Cornerstone of Chapel. St. Mary of the Lake Seminary. Area, Ill. B114 Brooks Photo

Mundelein and church dignitaries face the temporary altar during the ceremony. The *Chicago Daily Tribune* described the altar as "banked with ferns, palms, and crimson carnations, contrasting with the black and white of chanting acolytes, the purples of the robes of the monsignori, and the gold and white and cardinal red of the high churchmen's vestments." The *Tribune* reported a crowd of 30,000 at the ceremony. (BARC.)

Sealed within the cornerstone is a parchment with names of those participating in the service, seminary personnel, and church officials, as well as an issue of the archdiocesan newspaper. The translation from Latin: "This cornerstone of the University of St. Mary of the Lake was laid by the Most. Rev. George William Mundelein, third archbishop of Chicago, under whose administration and fostering protection this university was built this year of the Lord, 1924." (Photograph by author.)

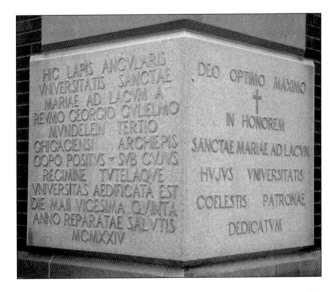

27

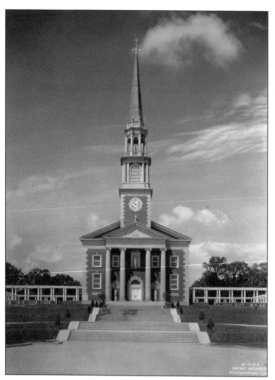

The Chapel of the Immaculate Conception (pictured at left in 1926) sits at the highest part of the seminary property. The chapel was modeled after the First Congregational Church in Old Lyme, Connecticut (pictured below in 2013), which Mundelein had visited as a young boy. Mundelein announced his architectural plans in an April 20, 1920 article in the *New World*, the archdiocesan newspaper. The article states, "It is a colonial church, a replica of the old Puritan meeting house now standing in Lyme, Connecticut, erected in 1815, and adapted to serve the purpose of a Catholic Church." The writer continues, "The entire room is finished in white enamel, relieved by the light buff color of the marble of the altars and sanctuary rail, and warmed by the amber glass that softens the day-light pouring in through the numerous windows." (At left, BARC; below, photograph by author.)

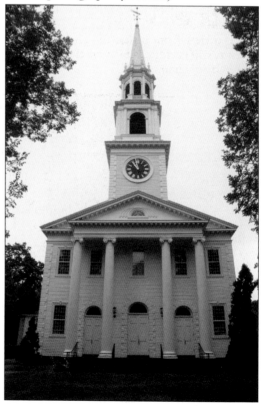

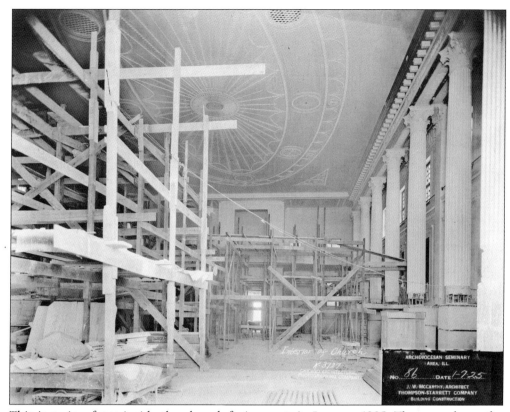

This is a view from inside the chapel, facing east, in January 1925. The area above the doorway will eventually become the overhead gallery, which will house the organ and hold the seminary choir. (BARC.)

By the time this photograph was taken in April 1925, the chandeliers had been hung and the marble had been laid. The altar will be constructed in the area where the man in the photograph is standing. (BARC.)

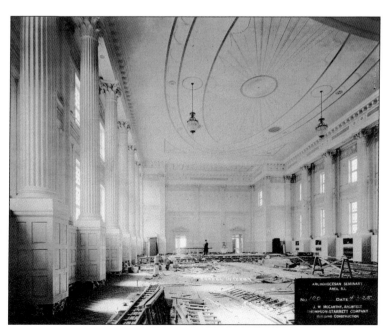

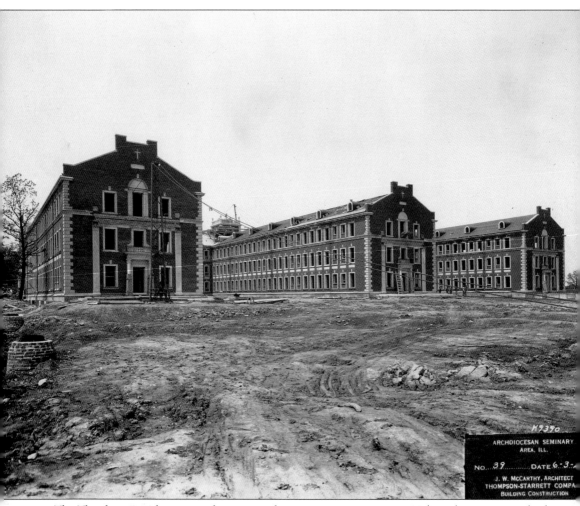

The Theology Residences can be seen under construction in June 1924. Each seminarian had a private room with a bath—a luxury in the 1920s, particularly for young men who came from immigrant families. Mundelein wanted his seminarians to be "splendidly equipped, in body, mind, in spirit," so they were provided with dorms, classrooms for study, chapels for prayer, and a gymnasium with a pool for recreation. (BARC.)

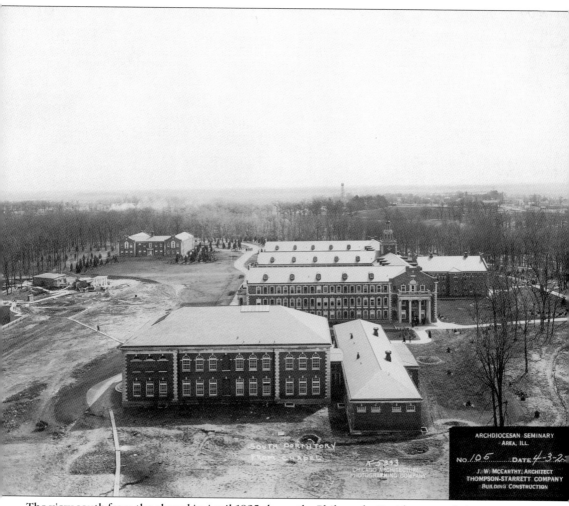

The view south from the chapel in April 1925 shows the Philosophy Residences and classrooms. To the far left in the photograph is the gymnasium, and at the top is the convent. Work was nearing completion on the gymnasium. The convent, which was completed in 1922, housed the Sisters of St. Francis of the Sacred Heart of Joliet, who took care of the domestic needs of the students and the faculty. (BARC.)

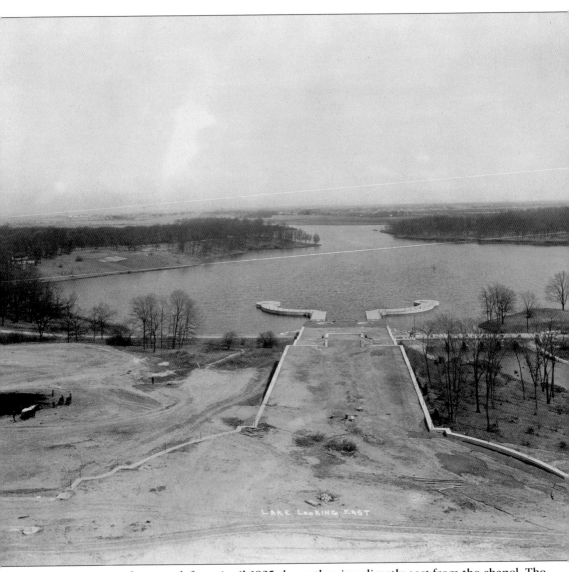

LAKE Looking EAST

A panoramic photograph from April 1925 shows the view directly east from the chapel. The footprint for the boathouse and belvedere can be seen jutting out into St. Mary's Lake. The

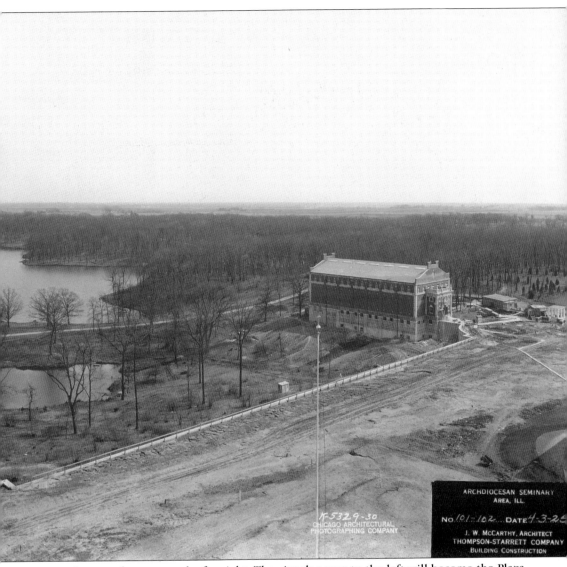

gymnasium can be seen to the far right. The circular area to the left will become the Plaza
of the Immaculate Conception. (BARC.)

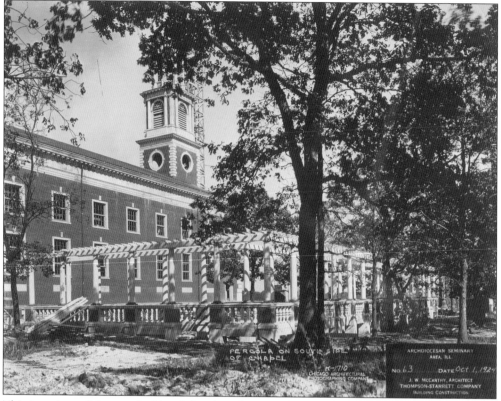

This is a view of the south side of the chapel in October 1924. The white pergola extended on both the north and south sides of the chapel. The pergolas eventually deteriorated and were removed, but a replica structure was built on the north side of the chapel when the McEssy Theological Resource Center was constructed in 2004. (BARC.)

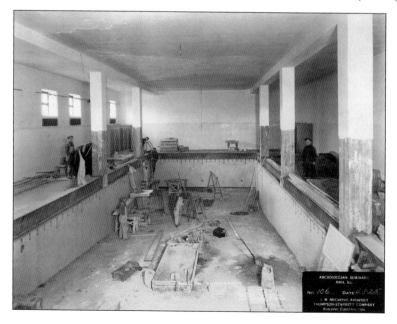

The pool was built on the lower level in the gymnasium, seen here under construction in April 1925. The pool was 24 feet wide and 60 feet long. Steam rooms, shower rooms, and dressing rooms for the seminarians were also built. (BARC.)

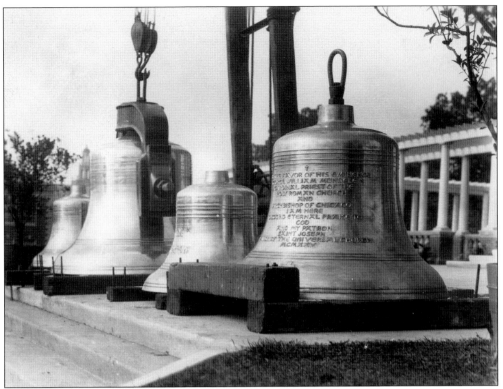

These 1925 photographs show the four bells that will be hoisted into the belfry of the tower of the Chapel of the Immaculate Conception. The bells, cast by the Meneely Bell Company of Troy, New York, are comprised of a four-to-one ratio of copper and tin. The largest bell weighs 7,000 pounds and the smallest weighs 1,500 pounds, each one sounding a different note. The bells have been striking in sequence every quarter hour at Mundelein Seminary since 1926. (BARC.)

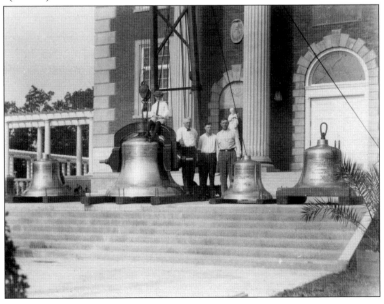

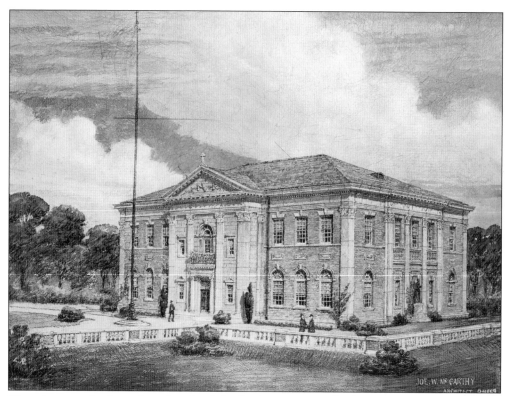

The photograph above is a sketch of the Feehan Memorial Library by Joseph McCarthy. Construction is underway in the image below from October 1928. The library was named after Archbishop Patrick Feehan, who was the first archbishop of Chicago. The library, recognized as one of the 250 greatest libraries in the world by the American Librarian Association, contains more than 200,000 volumes. (BARC.)

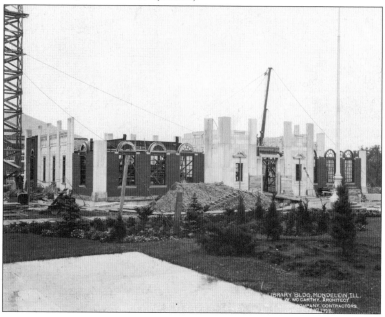

The Infirmary, pictured in 1928, consisted of the nurse's room, two private rooms, a doctor's office, two isolation rooms, a four-bed sick ward, and a solarium. (BARC.)

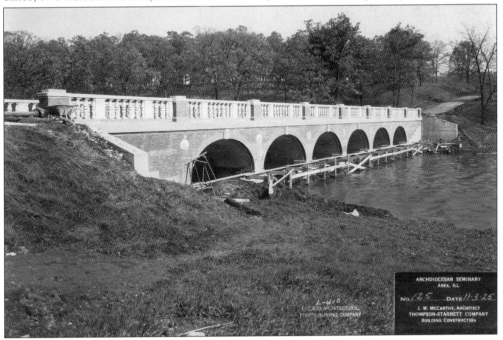

Construction nears completion in 1925 on one of the five bridges on the seminary property. The bridges are named after saints of the church. (BARC.)

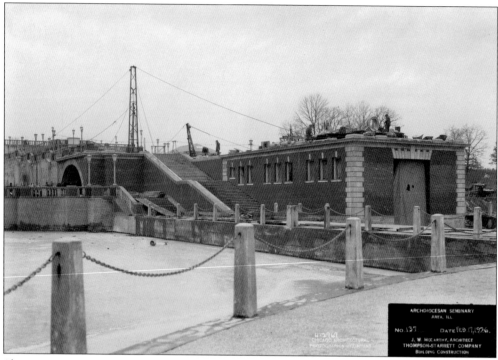

Above, construction is nearly complete in February 1926 on the boathouse and a portion of the stairs leading to the piers. The view from the top, seen below, shows the belvedere under construction. (BARC.)

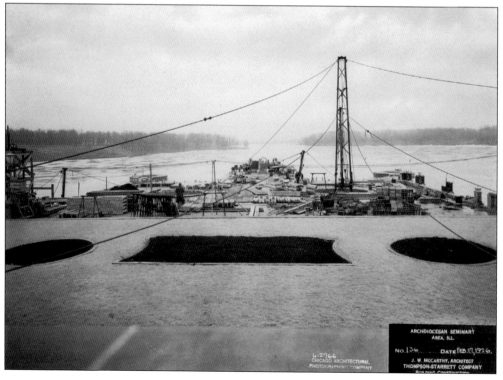

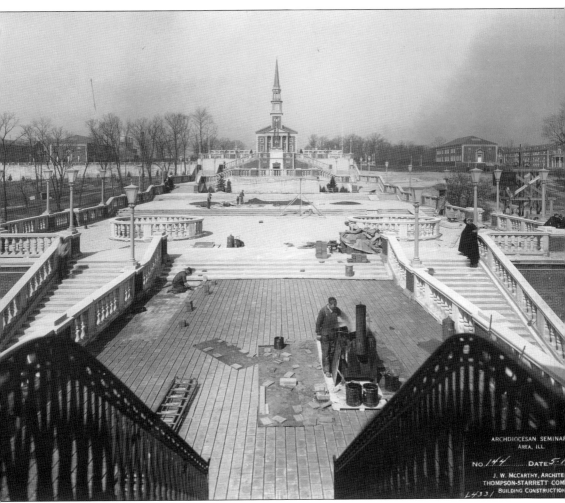

Within the image: ARCHDIOCESAN SEMINAR AREA, ILL. NO. 144 DATE 5-1 J. W. McCARTHY, ARCHITE THOMPSON-STARRETT COM BUILDING CONSTRUCTION L433I

Workers put the finishing touches on the belvedere in this May 1926 photograph. The view is from the belvedere directly west to the mall and to the Chapel of the Immaculate Conception. (BARC.)

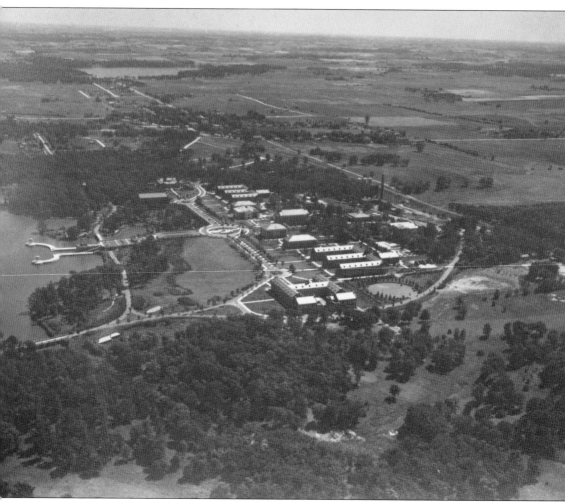

An aerial 1928 shot gives a good overview of McCarthy's design scheme for the seminary. The architect designed the main seminary buildings along the lines of a Latin cross on the west end of the lake. On the arms of the cross are the main residences and classroom buildings (the longer buildings). On the upright part of the cross, McCarthy placed the refectory, the chapel, and the boathouse that juts into the lake. In the center, where the cross intersects (the circular patch) is the Plaza of the Immaculate Conception, where a large statue of the Virgin Mary, the seminary's patroness, is located. (USML.)

Four

THE 28TH INTERNATIONAL EUCHARISTIC CONGRESS

A *New York Times* reporter called the closing ceremonies of the 28th International Eucharistic Congress in Mundelein the "largest religious meeting in the history of the Catholic Church in America."

On June 24, 1926, more than 800,000 people participated in the closing ceremonies, which included a Mass and a procession around the seminary grounds.

The event capped off a week of celebrations in Chicago from June 20 to 23 in 1926. Chicago was the first American city to host the International Eucharistic Congress, which celebrates the importance of the Eucharist in the lives of Catholics. A million people attended Mass at Soldier Field on Children's Day on June 21, an event that included a choir of 60,000 schoolchildren.

For the length of the congress, the city of Chicago and Cardinal Mundelein were on the international stage. On June 24, the focus was on the Mundelein Seminary. The seminary was described this way in the official International Eucharistic Congress souvenir book: "Here, in a setting which is indescribably beautiful, Cardinal Mundelein has reared his diocesan seminary, with seven magnificent buildings and a university faculty of Fathers of the Society of Jesus, the whole making what is easily the foremost Theological Seminary in the world."

Not only was the setting grand, the closing ceremonies were historic. The movement of people to and from Mundelein that day was the largest transportation effort in American history. Temporary train terminals were built to handle the crowds. Hundreds of police and volunteers monitored 400 miles of restricted highways for pilgrims flocking to Mundelein in cars, on rail, and on foot.

The International Eucharistic Congress showcased Chicago as a truly international city and elevated Cardinal Mundelein's status as both a spiritual and civic leader.

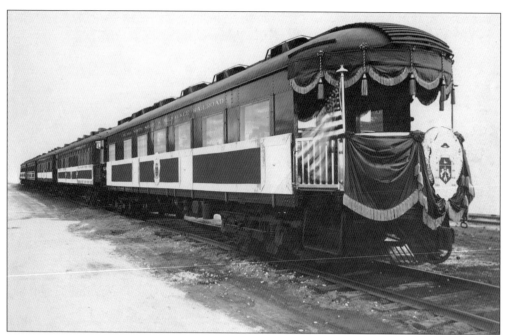

The Chicago, North Shore & Milwaukee Railroad (or North Shore Line) provided the "Cardinals' Special" train, pictured above, to transport church dignitaries from Chicago to Mundelein for the closing ceremonies of the 28th International Eucharistic Congress. The *St. Mary of the Lake* dining car, seen below at the Pullman Palace Car Company in Chicago, was one of seven that made up the "Cardinals' Special" that carried dignitaries from New York to Chicago for the International Eucharistic Congress over the New York Central Railroad. The dining car was equipped with fine linens and table silver engraved with the insignia of Card. John Bonzano, the papal legate (representative) to the congress. The cars were painted bright red, the color designated for cardinals. (Arthur Dubin Collection, Archives and Special Collections, Lake Forest College Library.)

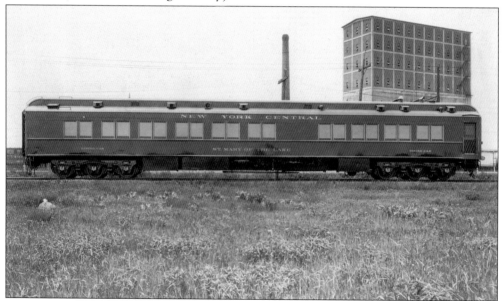

A group of men gathers outside a seminary building while workers place palm trees along the sidewalk in preparation for the closing ceremonies of the International Eucharistic Congress. The flag and shield of the congress adorn the lampposts. (USML.)

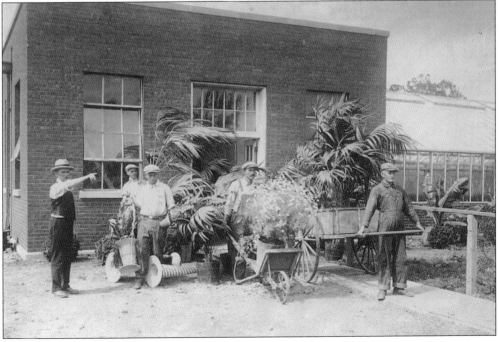

Groundskeepers discuss the placement of plants for the closing ceremonies at the seminary. The seminary greenhouse can be seen in the background. (USML.)

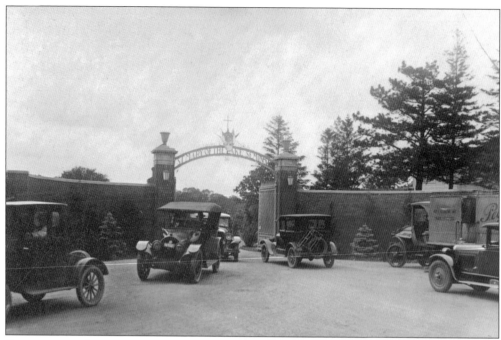

Cars are seen above going in and out of the entrance to Mundelein Seminary in June 1926. Two men talk to each other below in a makeshift parking lot for the International Eucharistic Congress closing ceremonies on June 24, 1926. Newspapers reported that approximately 18,000 cars moved in and out of Mundelein within a 24-hour period. Thousands of National Guard troops and volunteers patrolled the miles of roads to keep traffic moving after the end of the event. There were no reported problems. In fact, a *Chicago Daily Tribune* reporter noted that cars were able to reach speeds of 30 mph on the highways leading back to Chicago. (USML.)

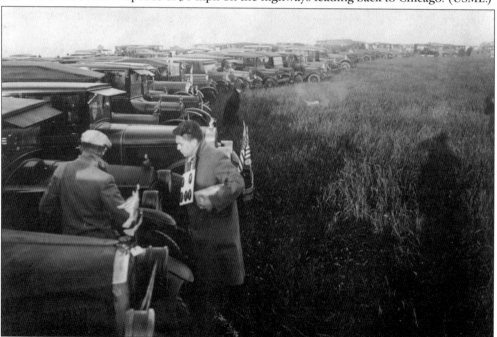

If they did not come by auto, visitors came to Mundelein by rail. The crowds in the image at right are waiting to buy tickets in downtown Chicago for the North Shore Line trains to Mundelein. The photograph below shows riders disembarking trains at the train station near the seminary. The North Shore Line and the Chicago Rapid Transit Company provided the bulk of rail service to the congress activities in Mundelein. A loaded train would arrive at the Mundelein station every 40 seconds over an eight-hour span. Over the course of 18 hours—from daybreak to midnight—820 trains (more than 5,200 cars) operated into or out of the Mundelein station. (USML.)

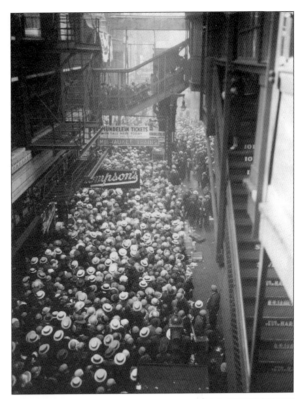

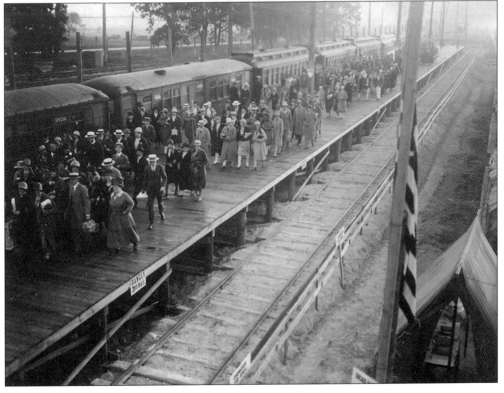

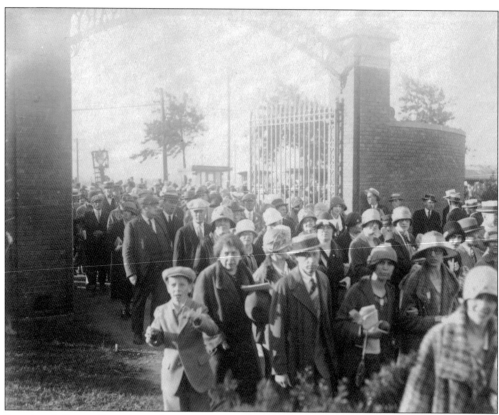

People of all ages flow through the gates (above) and across the bridges (below) of Mundelein Seminary, ready to take the one-mile hike to the site of the Mass. (USML.)

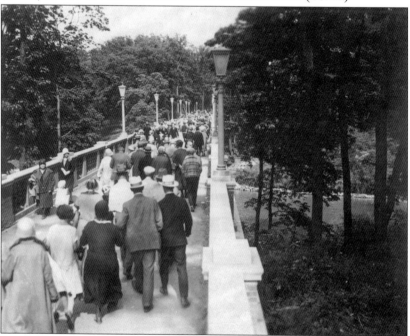

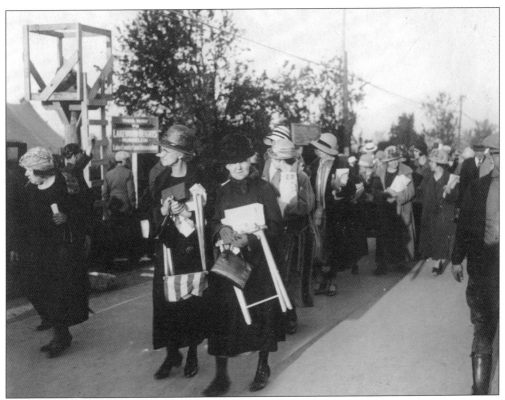

Visitors to Mundelein Seminary came prepared for the day, as illustrated above. Below, refreshments were available throughout the seminary grounds, as were restrooms. Drinking fountains were constructed every 100 feet, and 12 tents were set up for first aid. (USML.)

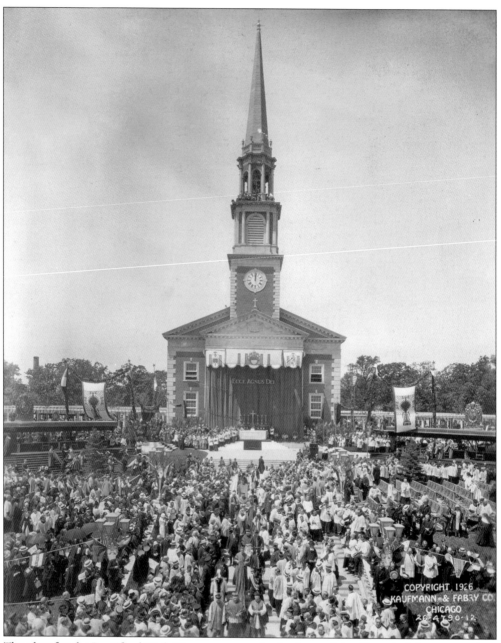

The altar for the Pontifical High Mass was set up in the front of the Chapel of the Immaculate Conception, showcasing the pageantry for the congress's Eucharistic Procession Day. A close look at the chapel reveals people standing in the belfry to garner better views of the Mass. (BARC.)

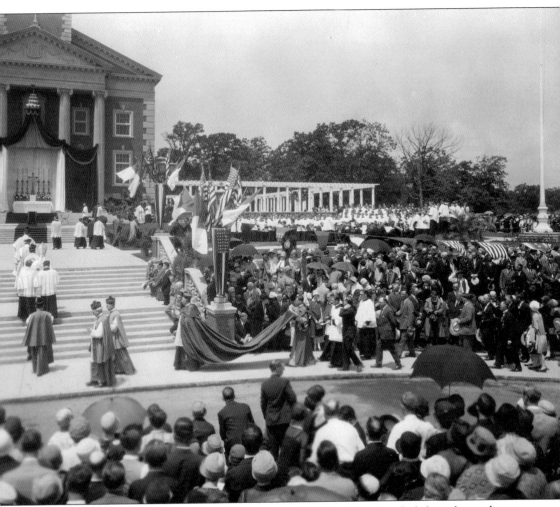

The Mass was celebrated by Cardinal Bonzano at 11:00 a.m. and ended three hours later. Card. Patrick Hayes, who was the archbishop of New York and a longtime friend of Cardinal Mundelein, preached the homily. (BARC.)

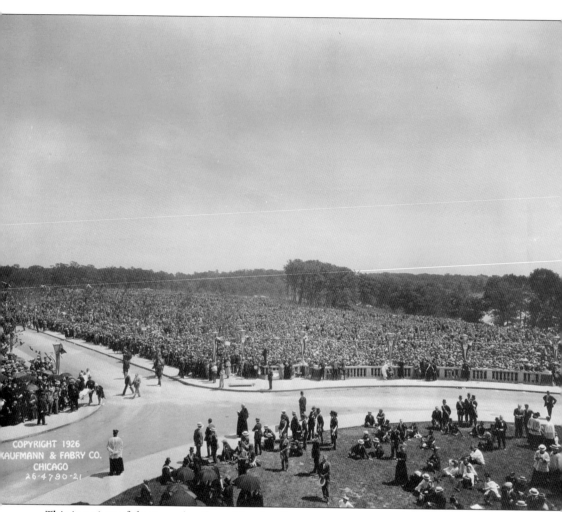

This is a view of the crowd gathered for the Mass on seminary grounds. Because the ground where the chapel is located is elevated, newspapers reported that everyone could see the Mass. Amplifiers assured everyone could hear. (BARC.)

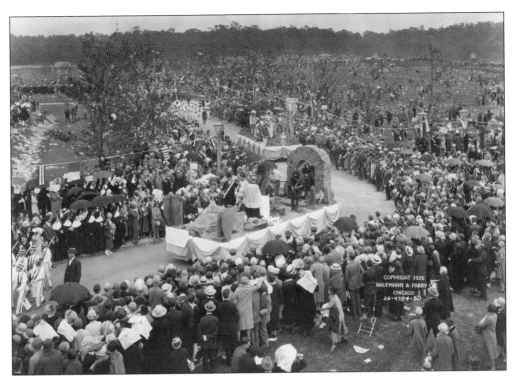

The Procession of the Blessed Sacrament started after the end of the Mass and proceeded around St. Mary's Lake. The procession included floats, bands, and units from various countries, as well as seminarians, priests, and cardinals. In all, 275 archbishops and bishops participated, as did 100 monsignors and some 10,000 members of the clergy and laity. (BARC.)

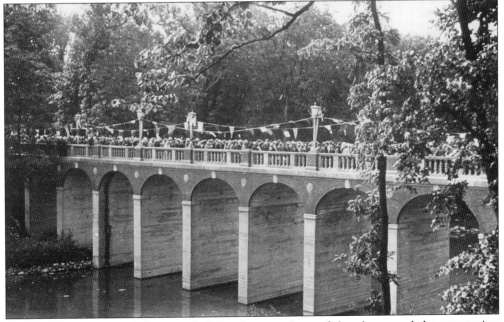

This is another view of the crowds following members of the clergy and the procession around the lake (BARC.)

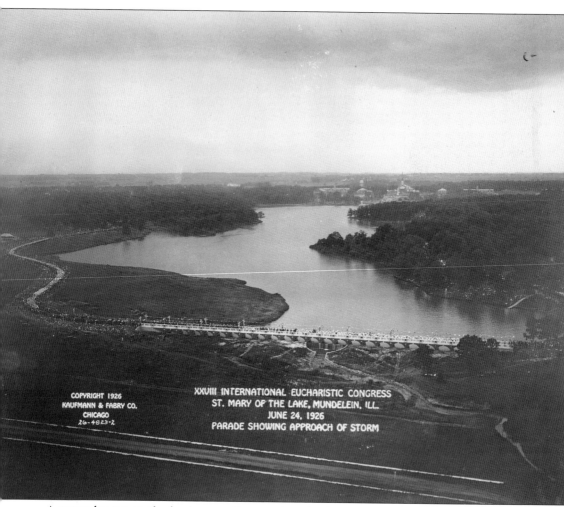

COPYRIGHT 1926
KAUFMANN & FABRY CO.
CHICAGO
26-4823-2

XXVIII INTERNATIONAL EUCHARISTIC CONGRESS
ST. MARY OF THE LAKE, MUNDELEIN, ILL.
JUNE 24, 1926
PARADE SHOWING APPROACH OF STORM

A storm looms on the horizon as the marchers in the procession make their way across a bridge. The crowds can be seen near the chapel and all around the lake. The storm hit at about 3:00 p.m., falling in sheets for 30 minutes. "Summer bluster," the *New York Times* reported. "Rain fell in torrents, followed by hail. Thunder came in sharp, crackling reports as lightning flashed across the sky." Visitors scattered, some panicking as they headed towards the exit and the trains; however, the procession continued. (BARC.)

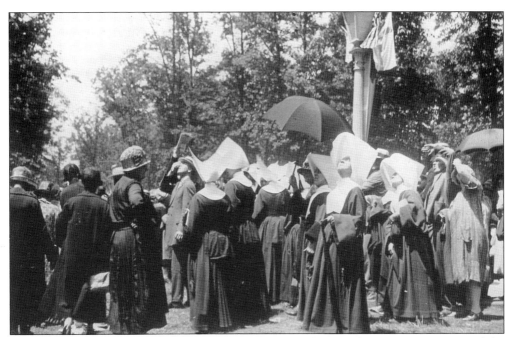

Nuns and other visitors to Mundelein look up to the skies, perhaps in anticipation of the coming storm. (BARC.)

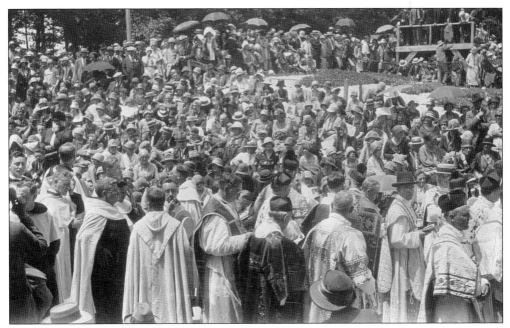

Umbrellas can be seen in the crowds as the clergy passes through during the procession. A reporter from the *Chicago Daily Tribune* noted that the cardinals and other clerics in the procession "gently motioned back" officers or pages who attempted to shield them from the rain with umbrellas. (BARC.)

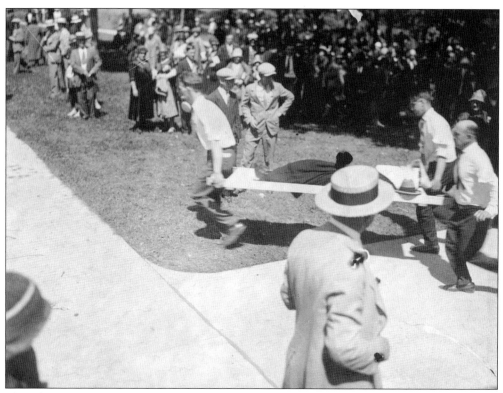

The *Chicago Daily Tribune* reported that 1,500 people were treated at emergency first-aid stations during the day, mostly for fainting and exhaustion, but some were seriously injured when panicked crowds rushed for the trains during the storm. The newspaper reported that 100,000 people jammed the temporary train terminal set up for the congress, with some being trampled. Three people suffered broken ribs, and one older lady suffered a fractured skull. Railroad officials urged calm, mostly out of concern about visitors falling onto the trains' electrified third rail. A reporter wrote, "Several priests climbed to the same vantage point and urged as a matter of common sense and Christian forbearance, that there be a letup in the jostling." (USML.)

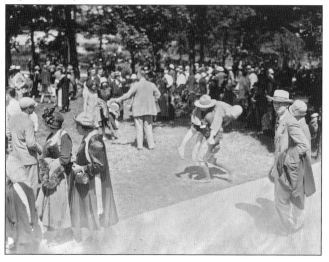

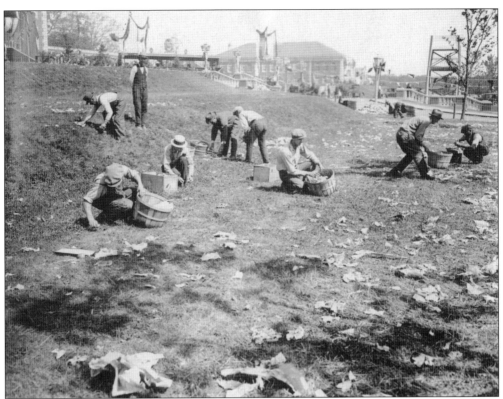

In the image above, workers clean up the piles of trash left after the celebration at Mundelein Seminary. The man in the photograph at right found an assortment of men's and women's hats, which were either lost during the day or discarded after the sudden rainstorm. (USML.)

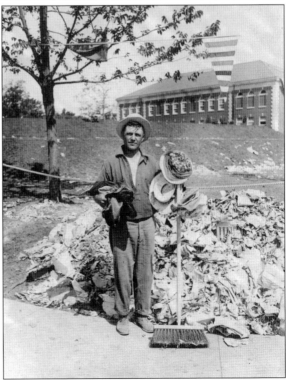

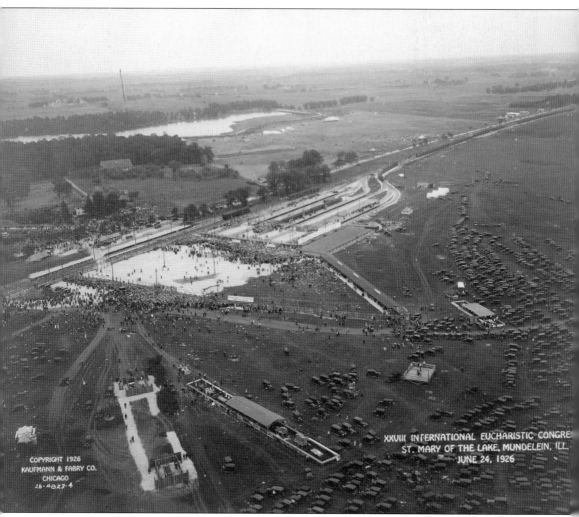

XXVIII INTERNATIONAL EUCHARISTIC CONGRE
ST. MARY OF THE LAKE, MUNDELEIN, ILL.
JUNE 24, 1926

In this aerial view of the aftermath of the congress, the temporary parking lots can be seen on the right, while the makeshift train terminals can be seen the center and St. Mary's Lake to the left. The North Shore Line constructed a six-track terminal opposite the seminary gates large enough for 52 railcars. To keep order, riders entered a stockade area and then were loaded onto trains from wooden chutes. Other passengers using the Chicago & North Western Railway were shuttled from Mundelein to new temporary train platforms in Lake Bluff. (BARC.)

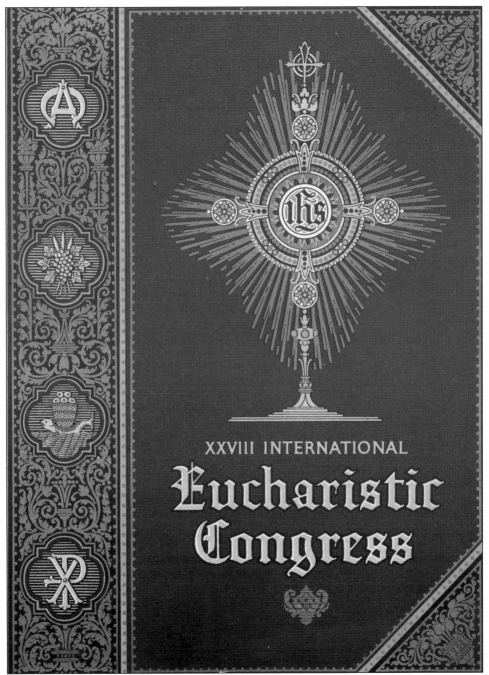

XXVIII INTERNATIONAL

Eucharistic Congress

This is the cover for the official program for the 28th International Eucharistic Congress. This was the first time the congress had been held in the United States. The book contained messages from Pope Pius XI and Cardinal Mundelein. In his message, Mundelein wrote, "And while it is true that this greatest religious demonstration this country of ours has ever seen takes place in Chicago, yet we are acting simply as the representatives of our Catholic brethren of America and the Congress belongs as much to them as to us." The program also includes itineraries for each day. (Fr. Matt Bozovsky.)

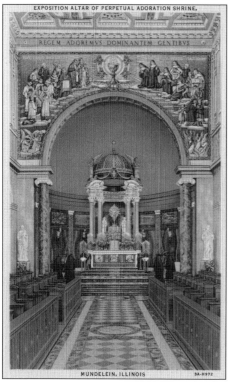

EXPOSITION ALTAR OF PERPETUAL ADORATION SHRINE,

REGEM ADOREMVS DOMINANTEM GENTIBVS

MUNDELEIN, ILLINOIS

Buoyed by the spirit of the International Eucharistic Congress, Cardinal Mundelein wanted a place for his seminarians to engage in Eucharistic adoration, a practice in which Catholics reflect and pray in the presence of the Eucharist. Mundelein solicited the services of Joseph McCarthy to design the Benedictine Convent of Perpetual Adoration, just east of the seminary. The image above shows the chapel under construction in 1930. Mundelein brought in the Benedictine Sisters of Perpetual Adoration of Clyde, Missouri, to operate the chapel and pray for the seminarians. The postcard at left shows the sanctuary in the adoration chapel. A mosaic in the arch above the sanctuary shows Cardinal Mundelein, priests, and seminarians in different stages of formation. The Benedictine sisters left in 1977, and the complex was taken over by the Conventual Franciscan Friars and renamed Marytown. (BARC.)

Five

THE GLORY
OF A VOCATION

In an open letter to clergy in 1934, Cardinal Mundelein wrote that many people thought his plans for the seminary were "an audacious rather than an ambitious undertaking." At times, Mundelein wrote, "Even I was a bit skeptical."

But Mundelein did not falter in his plans to prepare young men in mind, body, and spirit. "If we succeeded in giving the diocese for coming generations a clergy, well formed, well equipped, physically, intellectually and spiritually, all our expense, all our labors would be spent and richly rewarded," he wrote.

The seminarians had a beautiful place to play and pray; yet, they lived under very strict rules. Their day began at 5:35 a.m., followed by prayers and Mass, four classes, spiritual exercises, and study periods. Bedtime was at 9:45 p.m.

Classes were intellectually taxing and usually in Latin. Seminarians learned about philosophy, economics, poetry, English, Gregorian chants, and biology. They learned Latin, the official language of the Catholic Church, but also Polish, German, and Lithuanian.

Cigarette smoking, reading newspapers, or listening to the radio was not allowed. The seminarians could not leave campus and had but one short vacation in January. Many of them spent their summers in the seminary's summer camp in northern Wisconsin. Others worked at day camps operated by the archdiocese. Although the restrictions eventually relaxed, this strict regimen was in place for 44 years. "Life at a seminary can have many difficulties and hardships," one seminarian wrote in 1949, "but they all pale before the glory of a vocation and the joy that comes from striving to answer it."

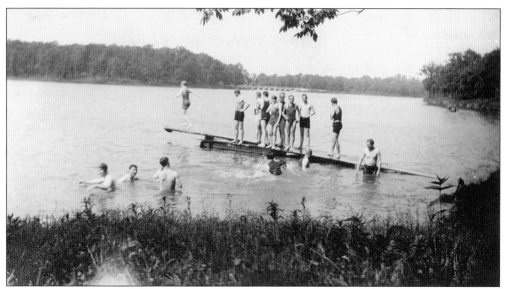

Seminarians swim in St. Mary's Lake in 1922. In January of that year, seminarians moved into their brand-new Philosophy Residences. (BARC.)

These seminarians were among the first to be ordained at Mundelein Seminary. The April 23, 1922, photograph shows the class gathered for a public disputation, where seminarians had to defend a thesis entirely in Latin. (BARC.)

John A. McMahon was one of 11 seminarians to be ordained at Mundelein on September 18, 1926. A second group of 24 young men were ordained in April 1927. Father McMahon, who had the title of monsignor at the time of his death in 1982, was pastor of St. Sabina Catholic Church in Chicago from 1952 to 1971. (The McMahon family.)

Not much is known about this photograph, but it was taken on October 5, 1921, the day the seminary started its first year of operation with 50 seminarians and five priests. The seminarians lived in temporary quarters in two buildings formerly owned by Arthur Sheldon until the new dormitories opened in January 1922. These seminarians were the first to complete the entire six-year course of studies in Mundelein. (The McMahon family.)

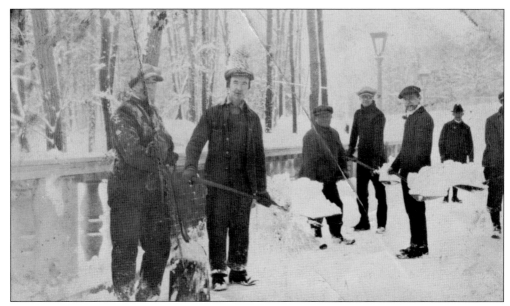

A 1920s photograph shows men removing snow from a bridge on campus. (USML.)

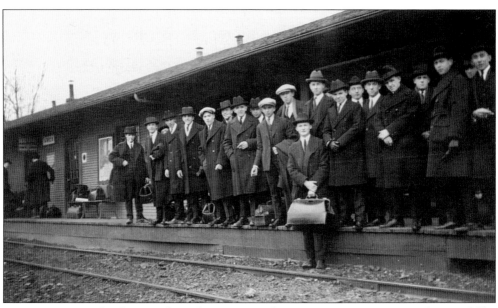

Seminarians wait for the train for a short vacation home on January 20, 1923. This would be their only vacation until June, when they would either go to northern Wisconsin for camp or work at various archdiocesan programs for the summer. (BARC.)

Three seminarians are having a little fun in this c. 1937 photograph. The seminarian in the center is wearing his Quigley prep sweater. Quigley Preparatory Seminary in Chicago, which Mundelein built and has since closed, was the minor seminary for the Archdiocese of Chicago. In 1937, approximately 71 out of the 88 new seminarians at Mundelein graduated from Quigley. (USML.)

The sisters of St. Francis of the Sacred Heart of Joliet were invited by Cardinal Mundelein to tend to the domestic needs of the seminary. They also ran the infirmary. Sister Anacleta, seen here in March 1922, was the seminary's first nurse. Wrote a seminarian in the 1930s, "The injured members don't hesitate to visit the Infirmary where through the skillful treatments of Sister Anacleta, they are quickly put back into the best of physical shape." (BARC.)

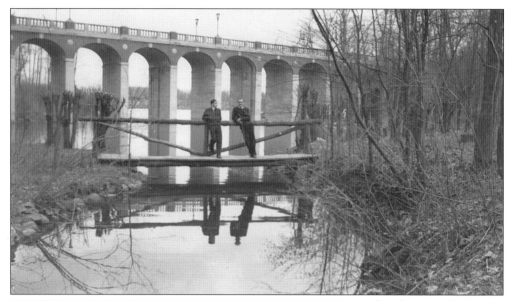

In the photograph above, two seminarians take time to relax along a bridge. At left, two seminarians look at a small creek. These photographs were taken during the 1937–1938 year of classes. (USML.)

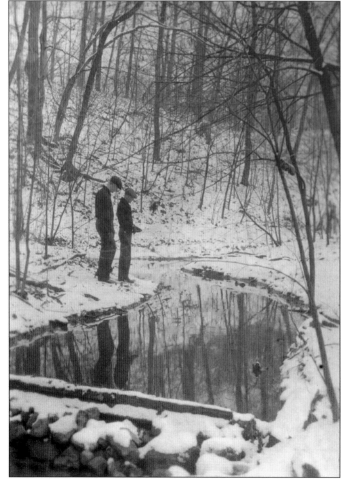

This is a view of the Chapel of the Immaculate Conception in 1938 or 1939. In the forefront is a stone pillar commonly known as the DIME, an acronym for the four Old Testament prophets David, Isaiah, Moses, and Ezekiel whose statues are located along its base. The column is 67 feet tall with a bronze 12-foot-tall statue of the Blessed Virgin Mary (the seminary's patroness) on top. The statue is a replica of the Column of the Immaculate Conception in the Piazza di Spagna in Rome. (USML.)

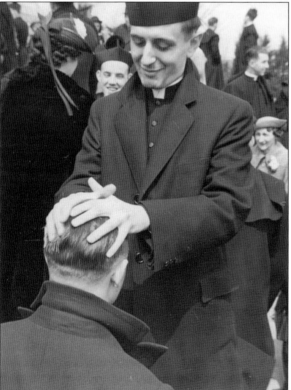

These photographs were taken after 38 seminarians were ordained to the priesthood by Cardinal Mundelein on April 15, 1939. A week later, the seminary celebrated St. George Day, the day each year that Mundelein treated the seminarians to a movie, days off from class, or fun raffles. On April 23, 1939, seminarians watched *The Hound of the Baskervilles* and participated in a raffle for six portable typewriters provided by Mundelein. (USML.)

Seminarians parade around campus in 1938 to kick off festivities for the annual Thanksgiving Day football game between the Theology and Philosophy Residences. Wrote one seminarian in 1939, "It is the one day in the year when the Seminary takes on the true college spirit." (USML.)

Seminarians could participate in different recreational activities, including billiards. Other sports included basketball, tennis, hockey, ping-pong, and handball. This photograph was taken in 1939 or 1940. (USML.)

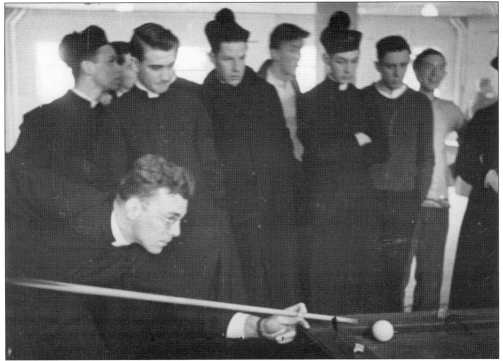

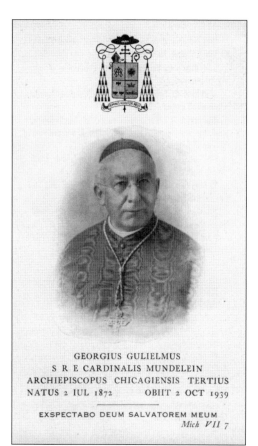

GEORGIUS GULIELMUS
S R E CARDINALIS MUNDELEIN
ARCHIEPISCOPUS CHICAGIENSIS TERTIUS
NATUS 2 IUL 1872 OBIIT 2 OCT 1939

EXSPECTABO DEUM SALVATOREM MEUM
Mich VII 7

On October 2, 1939, Cardinal Mundelein died of a heart attack in his home at the seminary. He was 67 years old. A copy of his prayer card is pictured at left. A seminarian wrote, "We, the future priests of the Archdiocese, owe to the third Archbishop our gratitude for Quigley, St. Mary of the Lake, the Villa (in Wisconsin) and the countless opportunities and advantages which he freely bestowed on us. . . . More precious than all these gifts, however, is the motive which begot them. They came to us from a paternal heart. They sprang from a generous heart. Above all, they arose from the heart of a true priest." He is buried the marble crypt seen below, beneath the altar of the seminary's chapel. The last line reads, "I shall wait for God my Savior." (At left, USML; below, photograph by author.)

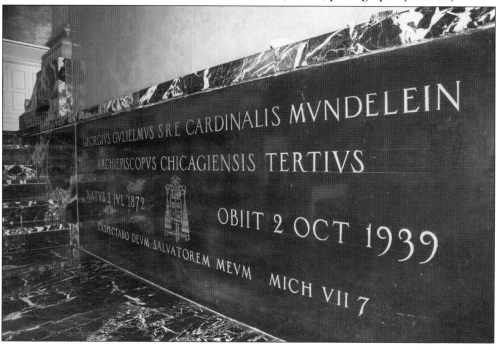

Terence J. Cahill (at right) was the first seminarian to be buried in the cemetery (below), located on the seminary grounds. He died on August 13, 1943, in Cook County Hospital from Infantile Paralysis, also known as polio. He was in his first year of studies and was only 20 years old. (USML.)

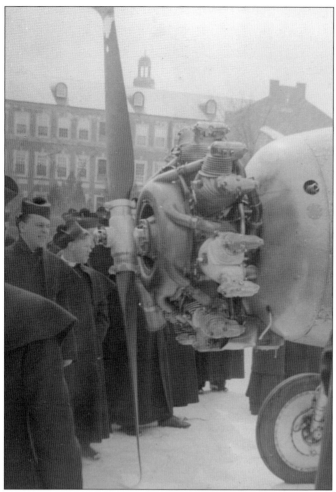

Seminarians surround a US Navy airplane that made an emergency landing atop a parking lot on March 9, 1943. The incident was recorded in the *Philosophy Chronicle*, a scrapbook kept by seminarians. The aviation cadets had been flying around the seminary for months as part of their training at Glenview Naval Air Station. One day, a cadet made an emergency landing on a ball field. An instructor, who had been flying nearby, encouraged the young cadet to follow his lead for the takeoff. The cadet, however, did not make it. He almost crashed into a dorm but with "amazing presence of mind, dropped in to the parking lot and swung to a stop into the surrounding hedges." Added the writer, "The only casualties were one slightly damaged plane and one very frightened, but very fortunate young Navy cadet." (USML.)

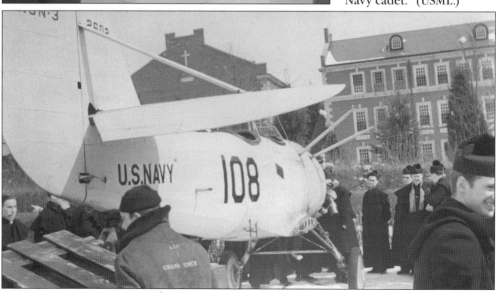

The seminary used to have a working farm on the property, which included 10 buildings (above). In 1942, the seminary owned about 250 acres of farmland, 40 of which were used for oats and corn, 20 for grapevines (for jelly and grape juice), and 20 more for nursery trees. The rest of the farm property was used for potatoes, garden produce, and sweet clover hay. Due of a lack of farmhands because of World War II, seminarians volunteered to help (below). (USML.)

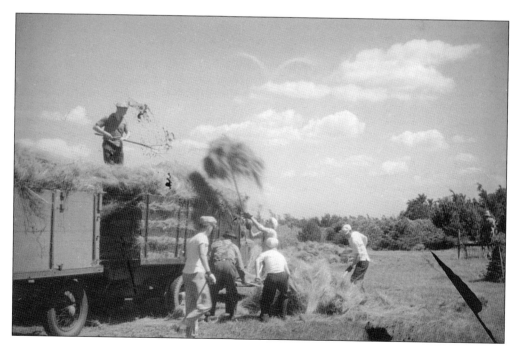

The farm also included a blacksmith, who used to shoe only two of the six horses and repair the tractors. Joked one seminarian in 1942, "Only two of the horses were shoed, since the others are never used on roads, [and] like seminarians, are not allowed outside of the grounds." The farm also included 70 pigs, which were destined for "St. Mary of the Lake's kitchen." (USML.)

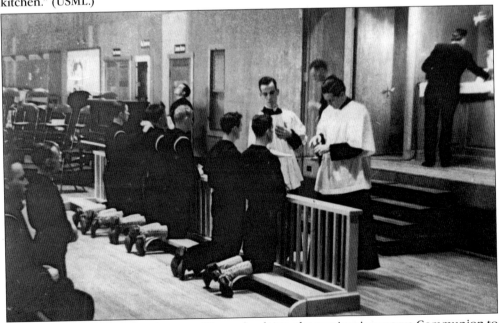

Helping to alleviate the burden on military chaplains, the seminarians serve Communion to the young men undergoing training at Great Lakes Naval Base in the 1940s. (USML.)

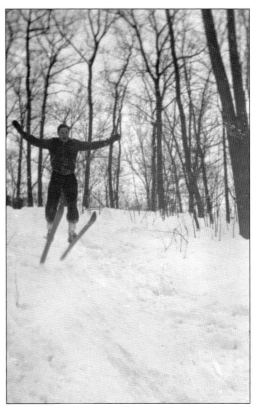

Seminarians took advantage of the wide-open spaces of the seminary to participate in winter activities. Skiing was a popular pastime, as evidenced in the 1941 photograph at right. There were reportedly 30 pairs of skis in the Philosophy Residence in February of 1943. Toboggan rides, seen below, and ice-skating were also popular. Wrote a seminarian in the *Philosophy Chronicle* in 1943, "Sun Valley, Idaho has nothing on the seminary on certain winter days." (USML.)

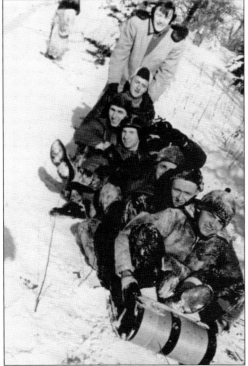

The seminarians also produced a series of plays each year, complete with costumes, makeup, and impressive sets. The image above shows the cast of the 1943–1944 play. *The Wizard of Oz* was the production for seminarians in March 1954, pictured below. (USML.)

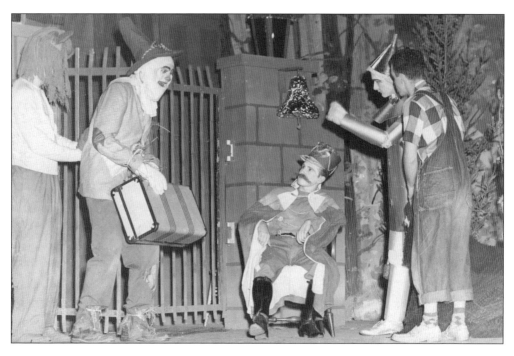

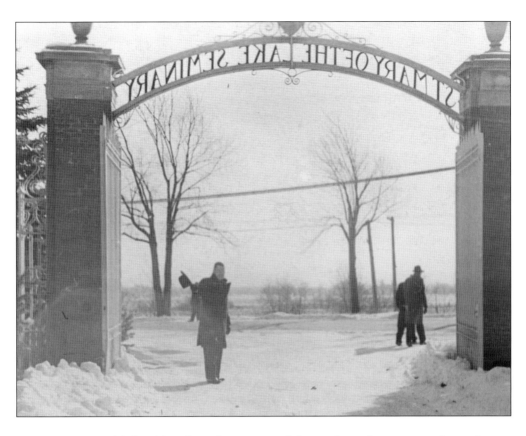

A seminarian tips his hat (above) on the way out of the seminary for a two-week vacation on January 23, 1947. With suitcases in hand, a group of seminarians (below) prepare for time off. (USML.)

Seminarians gather for mail call in this 1948 photograph. Wrote one seminarian, "Letters are wonderful, almost miraculous things. For these pieces of paper with strange markings upon them bring to the receiver not only the one who sends the letter but also the whole world in which the sender lives. A seminarian learns to appreciate the value of letters and perhaps as a priest he may well find that this reverence for letter writing will mean a lot to him in the very difficult task of saving souls." (USML.)

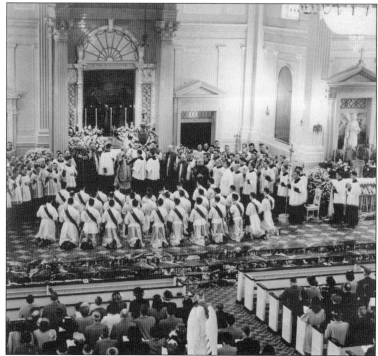

Thirty-three seminarians were ordained into the priesthood on May 3, 1947, by Card. Samuel A. Stritch in the main chapel. Cardinal Stritch followed Mundelein as archbishop of Chicago. (USML.)

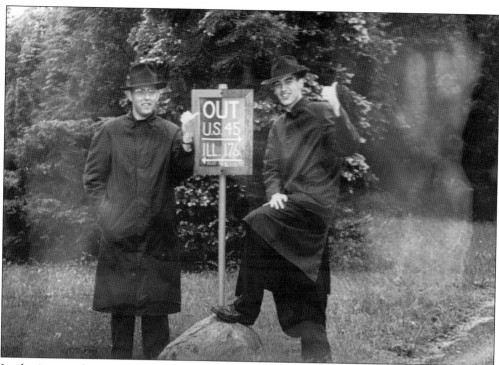

In the image above, two seminarians stand around a road sign signaling the two major intersections near the seminary, at Routes 45 and 176. Below, seminarians have a little fun during the cold winter months by building this snow bunny. Both photographs were taken during the 1950–1951 school year. (USML.)

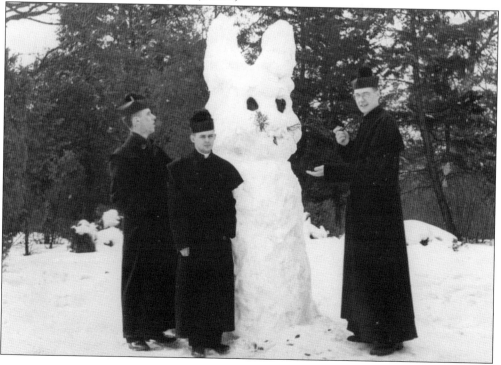

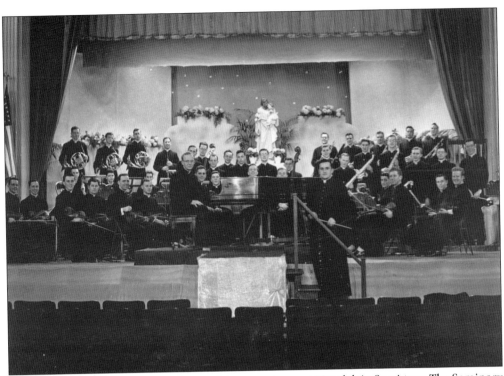

Music has always been an integral part of the experience at Mundelein Seminary. The Seminary Orchestra seen above poses for a photograph during what appears to be a Christmas concert in 1949. In the image below, seminarians perform as part of the Seminary Philharmonic during the 1951–1952 school year. (USML.)

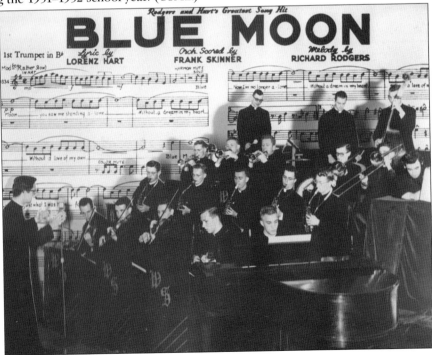

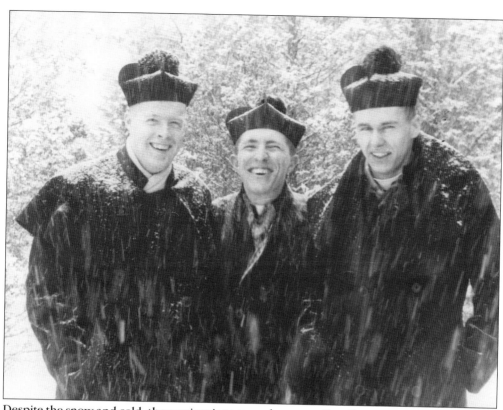

Despite the snow and cold, the seminarians seen above are all smiles in a c. 1952 photograph. Below, four seminarians take time out of their studies to relax around the lake in 1953 or 1954. After Mundelein's death, some of the strict rules were relaxed. For example, seminarians could now smoke outside during their recreation periods but not in their rooms. Radios, newspapers, and magazines, however, were still forbidden for most days of the year. (USML.)

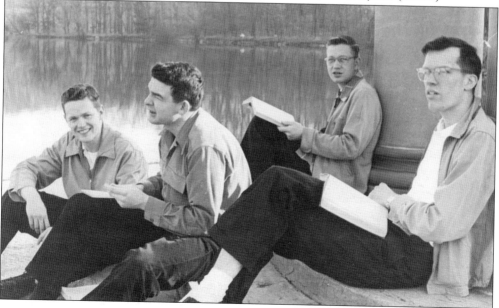

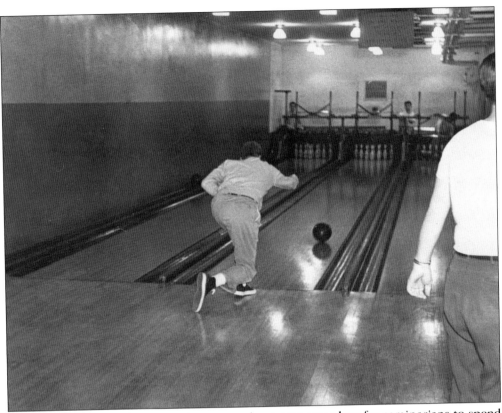

The bowling alley in the gymnasium, seen above, was one place for seminarians to spend leisure time in the early 1950s. The pins in the three-lane alley were manually set, as evidenced below by the three pinsetters. (USML.)

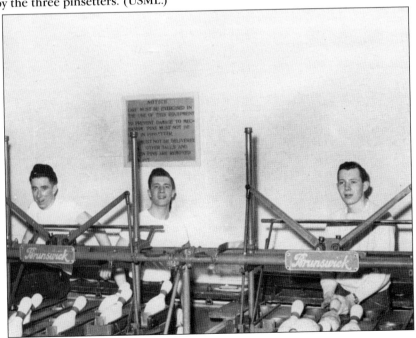

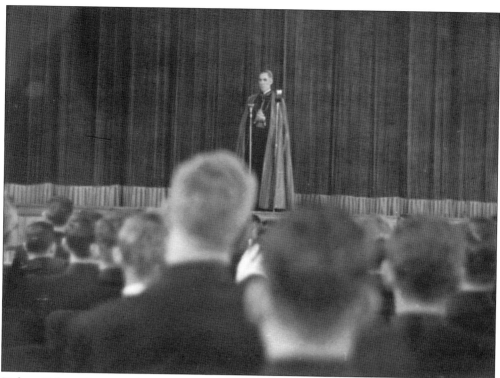

Bishop Fulton Sheen spoke to seminarians in May 1955 and posed for photographs. Sheen was a well-known personality in the 1950s and 1960s, having hosted radio and television shows, including the popular *Life Is Worth Living* program. Sheen encouraged the seminarians to be good speakers but told them "don't try to be like Bishop Sheen." "Everyone is a good speaker when he is alone," Sheen added. "Be humble about it. God will be working through you." (USML.)

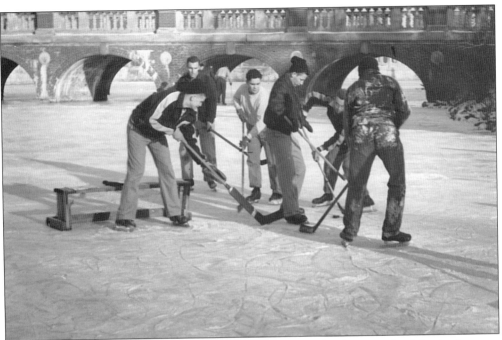

Seminarians take advantage of the frozen ice to play hockey on the lake in January 1956. (USML.)

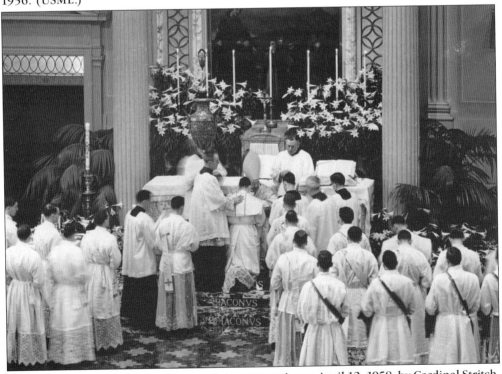

Thirty-four men were ordained as priests in ceremonies on April 12, 1958, by Cardinal Stritch, who left later in the week for a new job in Rome. He died less than two months later on May 27, 1958, in Rome. He was 70 years old. (USML.)

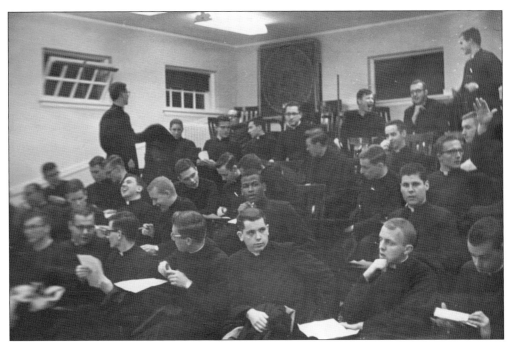

Seminarians are seen above in class in a c. 1965 photograph. Changes were starting to take place in the archdiocese and in the seminary with the installation of Archbishop John Cody in August 1965. The Jesuits, who led the educational system since the 1920s, were retiring and being replaced by archdiocesan priests. Students were allowed to smoke in their rooms, watch television, and could leave campus on their days off. In March 1966, the seminary's first vending machines, seen below, were installed. (USML.)

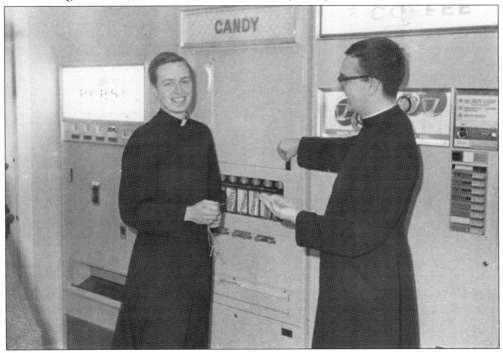

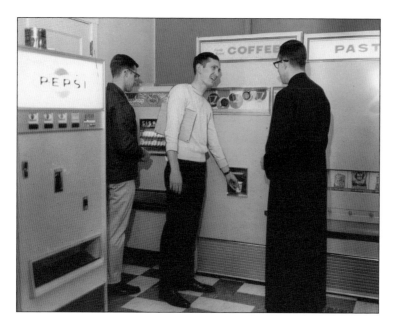

Seminarians meet at the vending machines for coffee and snacks in this March 1967 photograph. (BARC.)

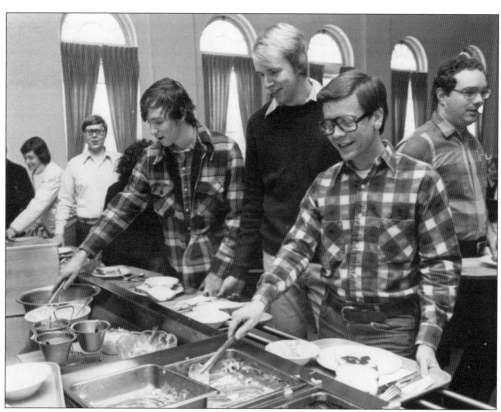

It's time for chow! Seminarians gather in the refectory for a meal in 1977. Three meals a day have been served up to seminarians since the building opened. (BARC.)

Six

PLAY AND PRAY

For nearly 45 years, seminarians from Mundelein have traveled to the Northwoods of Wisconsin to spend their summers at St. Mary's Villa.

Attendance at the summer camp was a requirement for theology students. Students on the other side of campus, in the philosophy school, spent their summers working in day camps or social programs run by the Archdiocese of Chicago. Both sets of programs were designed to keep the seminarians active and engaged year-round.

"The Villa," as it was affectionately known, was located along Clearwater Lake near Eagle River, Wisconsin, about five hours north of Mundelein. Catherine Higgins donated 2,000 acres of property to the archdiocese in 1922 after the death of her husband, John F. Higgins. Cardinal Mundelein decided in 1923 to utilize the property as a summer camp for his seminarians.

Those seminarians kept a record each year of their summers spent at the Villa in a scrapbook called the *Argus*. The articles and photographs in the *Argus* provide an intimate glimpse of life during the summer for these young men. While they had fun and played lots of baseball, the accounts also show how deeply dedicated they were to their vocation, their faith, and to their church.

While the summers at the Villa were not as historically significant as, say, the International Eucharistic Congress, the camp holds its own special place in the history of the seminary and in the hearts of its seminarians.

Wrote one seminarian in August 1937, "Morning, noon and evening, we are doing something together. If you ask 'Why?' my only answer is . . . that's the Villa. We pray together, play together; that's the Villa too. Prayer and play—together for God—that's the essence of Villa life; unparalleled and we are grateful for it."

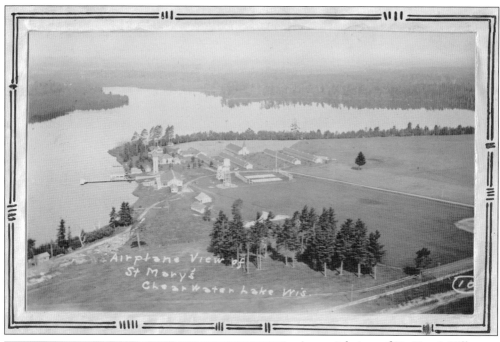

Airplane View of St Mary's Clearwater Lake Wis.

An aerial view of St. Mary's Villa shows the camp buildings and Clearwater Lake on July 25, 1928. The Villa was the summer home for seminarians from 1923 to the mid-1960s. (USML.)

What is summer without relaxing under a big tree? That is what these seminarians are doing in an August 1929 image. The caption under the photograph reads, "A scene of active life in the Villa." (USML.)

The Villa's main news source was the *Argus*, which can be seen hanging on a news board in this image from August 1931. An *Argus* reporter wrote this in 1949, "Since the first copy in 1927, this paper has been the eyes and ears of the Villa." (USML.)

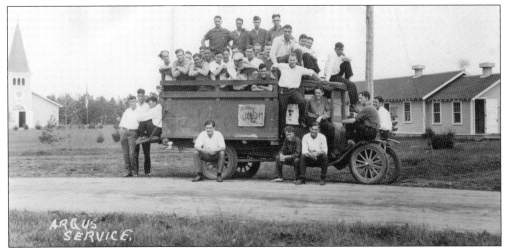

Members of the *Argus* press staff pose for a photograph on June 13, 1929, before leaving to cover the next day's big baseball game. The *Argus* staff promised readers they would receive play-by-play accounts of the game, a box score, and more on the news board within 10 minutes after the end of the game. (USML.)

Seminarians relax outside one of the dorms at the Villa in 1929. (USML.)

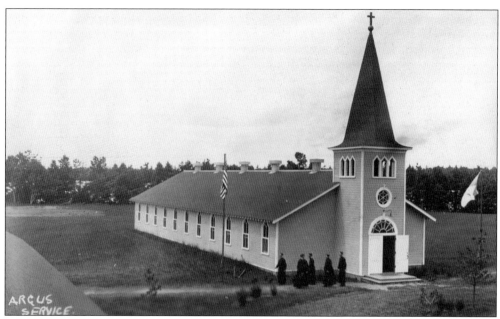

Seminarians walk in front of the chapel at St. Mary's Villa. Despite the vacation atmosphere, seminarians still had to continue their spiritual studies and adhere to strict rules. They rose by 6:00 a.m., were in the chapel by 6:25 a.m., and had Mass at 7:00 a.m. The rest of the morning was filled with spiritual reading. The afternoon included recreational activities, followed by night prayers at 9:40 p.m. Lights were out by 10:15 p.m. (USML.)

Plenty of recreational opportunities were available for seminarians. Swimming and diving contests were popular, as evidence in this July 1934 photograph. (USML.)

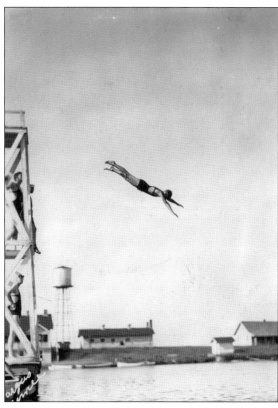

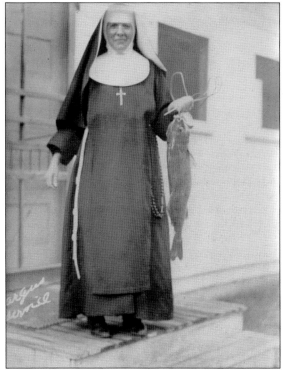

Fishing was a popular pastime. Sister Cleta, who was the head cook of the seminary for more than 50 years, caught this fish at the Villa while visiting on August 2, 1934. The 8.5-pound walleye was the best catch of the season. (USML.)

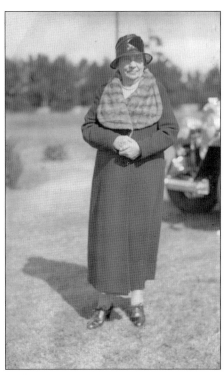

Catherine Higgins, seen at left in July 1933, donated the property for the Villa after the death of her husband. She also donated $10,000 for construction of the Villa chapel. In gratitude, seminarians performed a birthday skit for Higgins, pictured below in July 1938. (USML.)

Seminarians were always ready to lend a hand when needed in the community surrounding the Villa. They provided support to firemen fighting a nearby forest fire on August 8, 1936. (USML.)

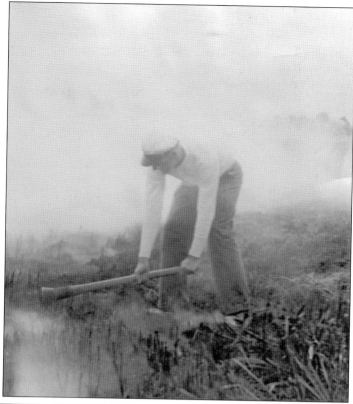

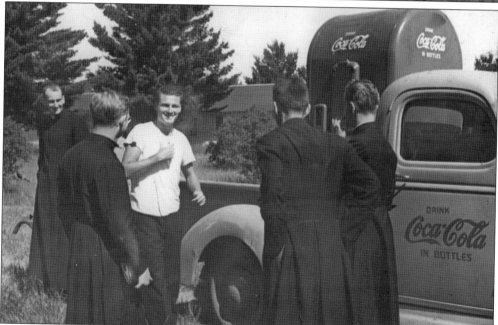

The soda machine arrived for the first time at the Villa in 1947. The *Argus* reported the 800-pound machine was installed in the recreation hall, and 12 cases (or 288 bottles) were sold the first day at a price of 5¢ a bottle. (USML.)

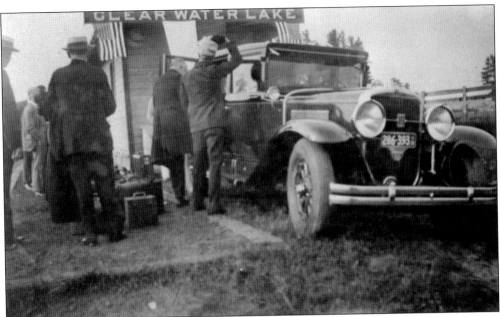

As indicated earlier, Cardinal Mundelein was a frequent visitor to the Villa. His arrival was always met with excitement. After arriving on the "Fisherman's Special" at the Clearwater Lake train depot, Mundelein (above) enters a car for the ride to the Villa in July 1928. Seminarians used to line up along the road to greet the cardinal like they did in August 1930 (below). As a reporter from the *Argus* wrote, "Once again, the Chief is with his boys." (Both, USML.)

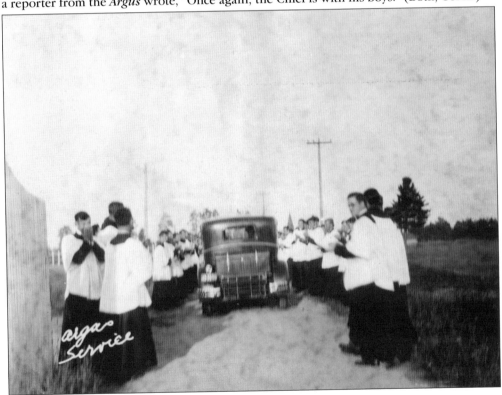

Mundelein and other visiting dignitaries enjoyed watching seminarians participate in the many Villa events. He threw out the first pitch to start the baseball season on July 29, 1935. (USML.)

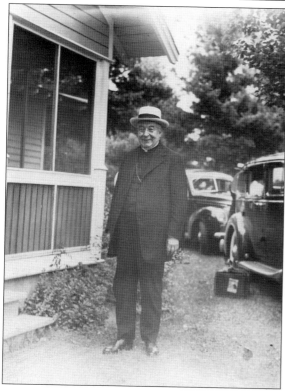

Mundelein poses for a photograph on August 4, 1939. He died less than two months later. (USML.)

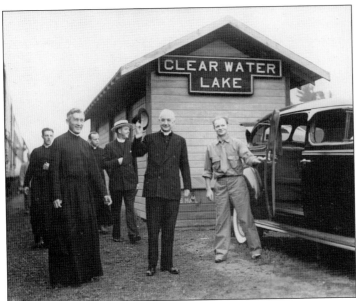

Cardinal Stritch waves after arriving at the train depot on August 12, 1940. Although Stritch did not visit the Villa as frequently as Mundelein, he did make the occasional trip. (USML.)

The Apostolic delegate to the United States, Amleto Giovanni Cicognani (left) and Archbishop Edward F. Hoban visit the Villa in August 1941. Cicognani, who was elevated to cardinal in 1958, later became the Vatican secretary of state and the dean of the College of Cardinals. Hoban was a close associate of Mundelein's and, at the time of this photograph, was bishop of the Diocese of Rockford, Illinois. Hoban was also president of the executive committee that planned the International Eucharistic Congress in Chicago. (USML.)

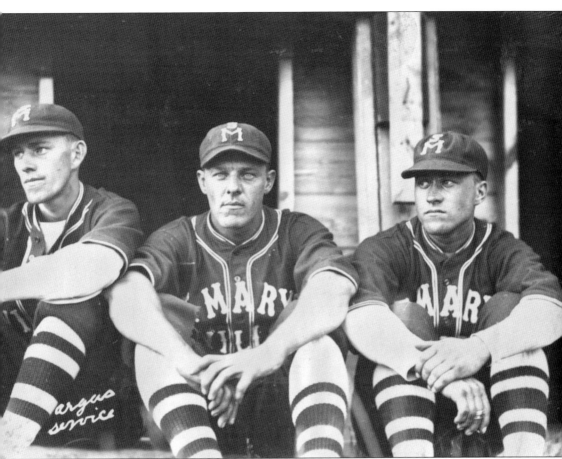

Baseball was the most notable activity for seminarians during their summers at the Villa. Reporters for the *Argus* spent most of their time covering games of the St. Mary's Villa teams. Many of the photographs, like this one from 1933, are iconic illustrations of America's favorite past time. (USML.)

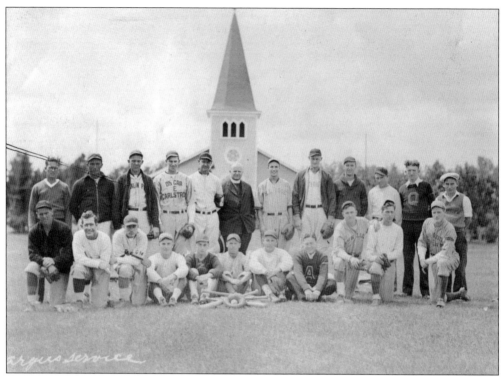

The teams from St. Mary's Villa played teams from nearby towns in Wisconsin, such as Minocqua, Eagle River, Rhinelander, and Land O' Lakes. By 1933, the team (below) had uniforms with "St. Mary's Villa" across the front. (Both, USML.)

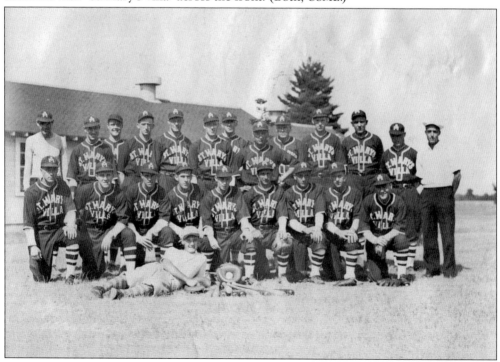

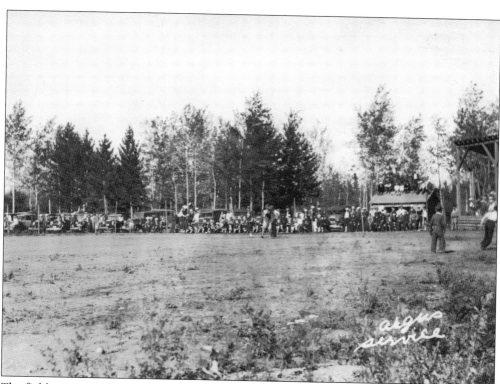

The fields were not fancy, but there always appeared to be a crowd at the games. The St. Mary's Villa team took on the team from Land O' Lakes on the road in the summer of 1933. (USML.)

Seminarians cheer on their team during a game on June 10, 1939. (USML.)

A poster from 1933 advertises an upcoming baseball game between the "Student Priests" of St. Mary's and the Rhinelander Ripcos. It appears to be a good deal for a 25¢ admission. (USML.)

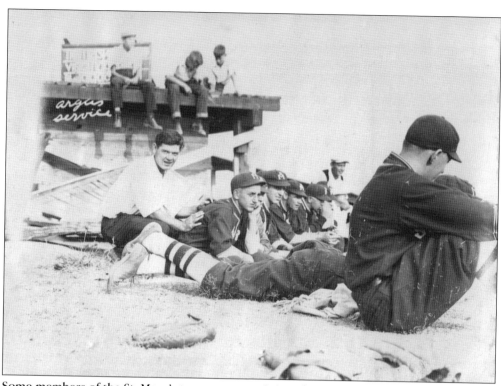

Some members of the St. Mary's team are seen sitting along the sidelines in a game against Rhinelander in 1933. (USML.)

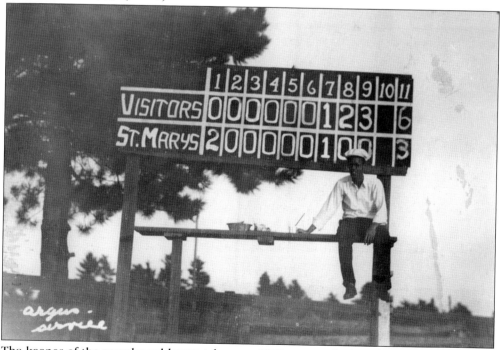

The keeper of the scoreboard keeps tabs on a 1933 game, which unfortunately shows the St. Mary's team down by three in the top of the 10th inning. (USML.)

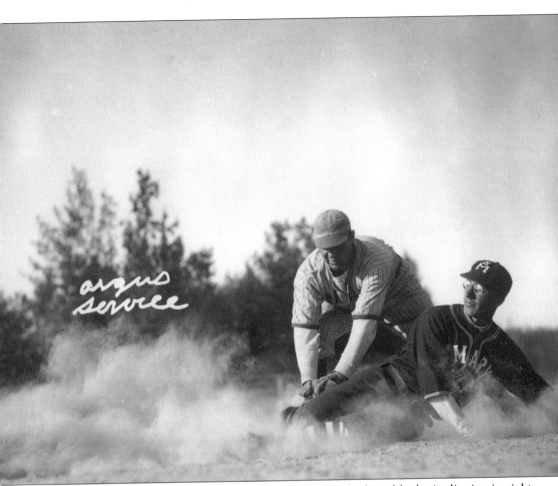

A St. Mary's player slides into a base in a July 1934 game looking like he is slipping in right under the tag of the opposing player from Phelps. (USML.)

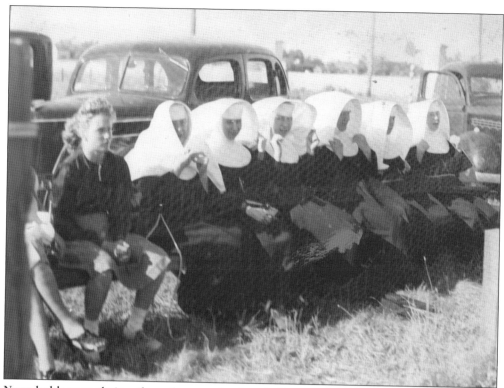

Nuns holds onto their veils as they watch a baseball game in 1946. (USML.)

A baseball player from St. Mary's Villa poses for a photograph on July 4, 1949, with a player from the opposing team, the Watersmeet (Michigan) Lakelanders. (USML.)

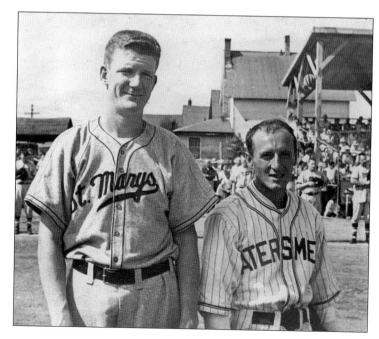

Seminarians look at a poster advertising a baseball game between the Watersmeet Lakelanders and St. Mary's Priests in 1953. (USML.)

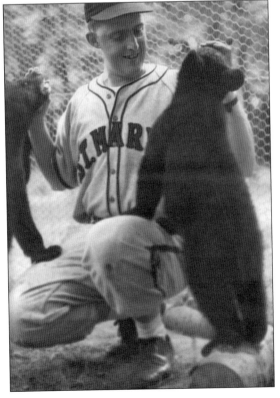

During a trip to the Eagle River, Wisconsin, area in 1953, the St. Mary's baseball team came across a cage with two bear cubs. Armed with marshmallows, two of the players decided to go into the cage for a closer look and a photograph. According to the *Argus*, "The marshmallows proved more attractive in the long run than either the camera or Joe's leg." (USML.)

Members of the St. Mary's Villa team relax in the dugout during a baseball game in 1952. (USML.)

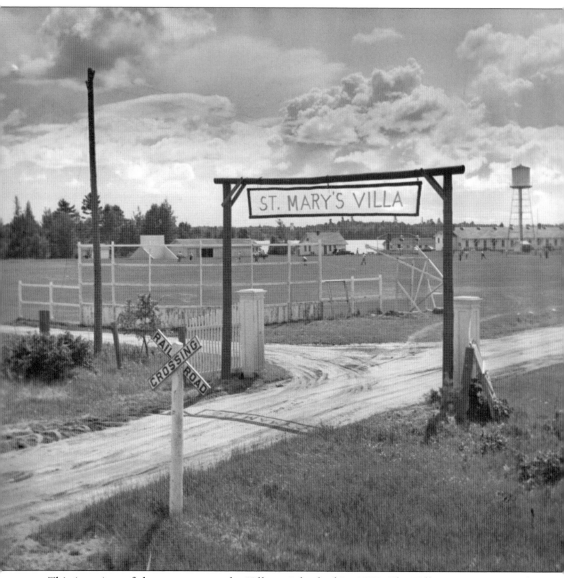

This is a view of the entrance to the Villa as it looked in 1953. The Villa experience can be summed up by this seminarian in 1938: "This summer has put us all together, has made us realize the best part of a Villa vacation is the companionship and spirit of our fellows. That spirit has made of us one, giving us a chain to bind ourselves together for life." (USML.)

Seven

BRICK AND STONE WALLS

In 1934, the Cardinal Mundelein Auditorium opened, marking the official completion of the building program at Mundelein Seminary. In an address to mark the occasion, Mundelein thanked the clergy and faculty for "building up a love of study and a spirit of piety, and the fine traditions that are a part of St. Mary's as are its brick and stone walls."

Those "brick and stone walls" look the same today as they did in the 1920s. Some buildings have been repurposed, but for all intents and purposes, the aesthetics of the campus have not changed. There is only one exception. An addition was built onto the Feehan Memorial Library in 2004. The McEssy Theological Resource Center was the first and only new building to be constructed on campus since the auditorium was built in 1934.

This final chapter takes a look at the seminary's past and present, linking those "fine traditions" of which Mundelein spoke about in his speech. Even as the seminary enters into the end of its first century, it remains the essence of Mundelein's grand vision.

William O'Carroll, pictured above, was the seminary's groundskeeper for nearly 50 years. Cardinal Mundelein admired the landscaping of Chicago's Lincoln Park, so he hired O'Carroll from the Chicago park system for his seminary project. O'Carroll, also seen at left, lived in a house near the entrance with his family. A daughter, who visited the seminary in 2009, said she remembered her mother and father sneaking in such contraband as vanilla ice cream and apple pies to seminarians at a drop-off point near the home. (Above, BARC; at left, USML.)

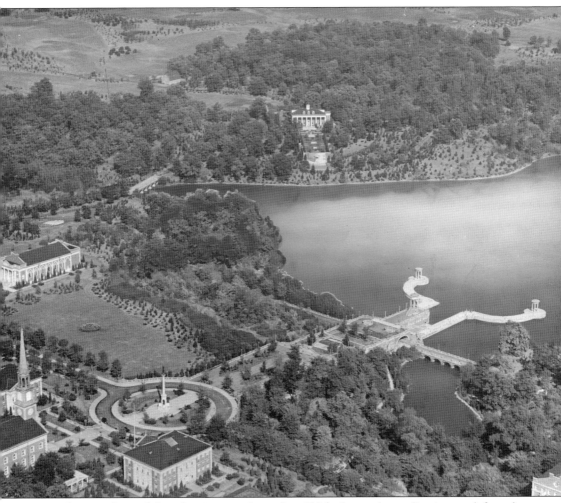

An aerial view of Mundelein Seminary, taken after 1934, shows the auditorium at left and the Cardinal's Villa at the top. The Chapel of the Immaculate Conception can be seen in the lower left, with the administration building to the right. The DIME statue can be seen in the center of the circular drive, which then goes out to the belvedere into the lake. The pier-like extensions of the belvedere were inspired by the structures that were supposed to be built into Lake Michigan as part of the 1906 Burnham Plan of Chicago. (BARC.)

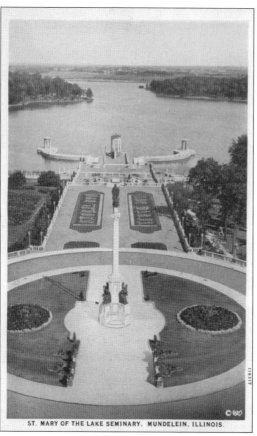

A postcard image from the 1920s or 1930s shows the DIME statue and the mall leading out to the lake. A closer look at the flower beds reveal words written in Latin. (Author's collection.)

ST. MARY OF THE LAKE SEMINARY, MUNDELEIN, ILLINOIS.

A view from the mid-1960s shows very different landscaping surrounding the DIME statute. Trees almost obscure the view to the lake. (USML.)

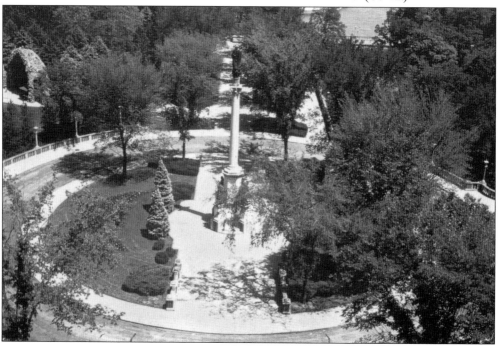

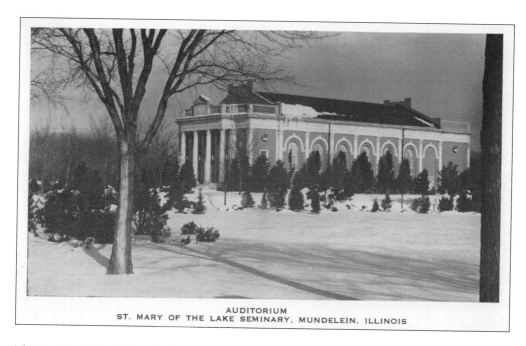

AUDITORIUM
ST. MARY OF THE LAKE SEMINARY, MUNDELEIN, ILLINOIS

The Cardinal Mundelein Auditorium is seen above in a postcard view in the winter. Another view of the auditorium is seen below; both are likely from the late 1930s. The auditorium was the last major building constructed under Mundelein's direction on campus. It features 800 seats, a large stage, and an orchestra pit. It is also the home for the Howell-Wurlitzer Organ, one of the nation's top theater organs. (Above, author's collection; below, USML.)

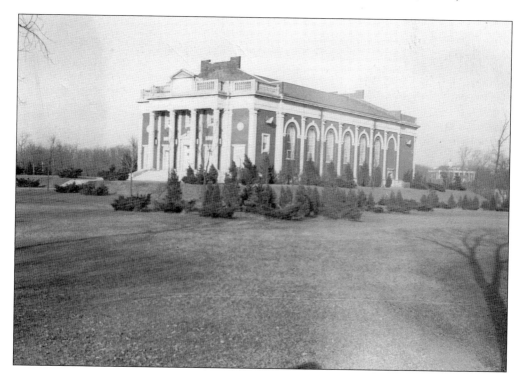

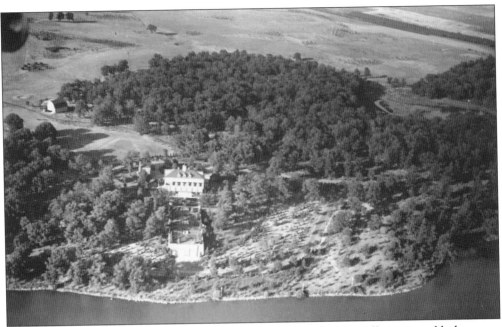

The Cardinal's Villa can be seen above in a 1936 aerial view. The villa, pictured below, was the lakefront home for Mundelein, which was given to him as a present to celebrate the 20th year of his consecration. In the book, *The First Cardinal of the West*, the writer called the Cardinal's Villa, completed in 1932, a "residence to which His Eminence retires from time to time for rest or to formulate plans away from the distractions of Chicago." Mundelein died in his villa bedroom in 1939. (BARC.)

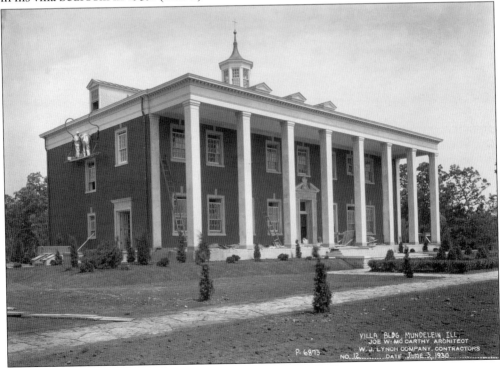

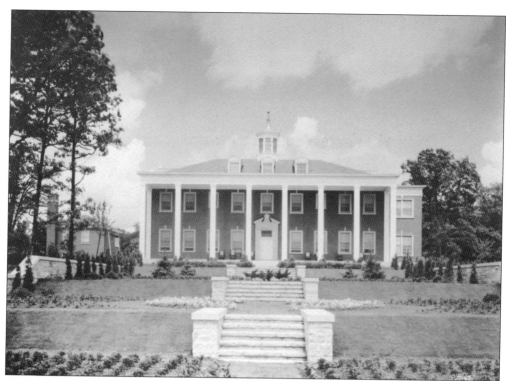

McCarthy designed the villa (above) in the Colonial style. The residence is modeled on George Washington's Mount Vernon home (below). The building is two stories tall and has 14 rooms. (Above, USML; below, photograph by Rob Shenk, courtesy Mount Vernon Ladies' Association.)

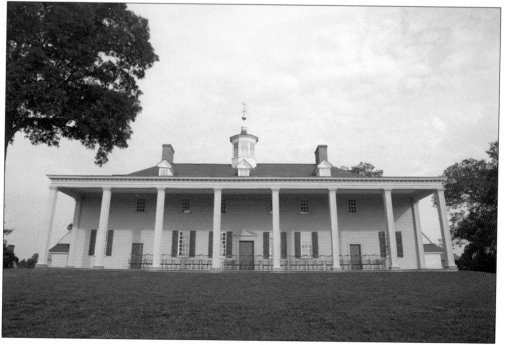

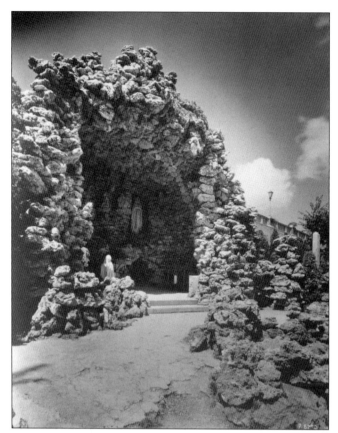

A popular stop on a tour of Mundelein Seminary has been the Our Lady of Lourdes Grotto, seen at left in the 1930s. The grotto, which symbolizes the shrine in Lourdes, France, was located for many years on the southeast side of the mall and was open to visitors in 1926 during the Eucharistic Congress; however, it was moved to the north side of the mall, just south of the auditorium. The new grotto, pictured below, was dedicated on May 31, 1962. (USML.)

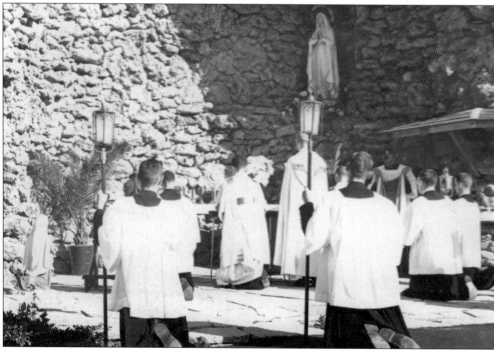

Another view of the Grotto shows its new location north of the mall and west of the lake. (USML.)

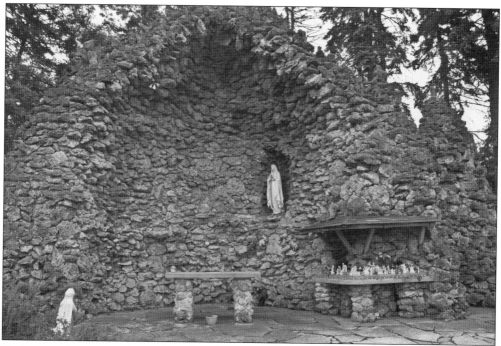

Visitors to the grotto site today often leave small candles, angel figurines, or rosaries as symbols of their prayers to the Virgin Mary. Small pieces of paper with prayers can be found tucked into stone precipices. The Lourdes story involves a young girl named Bernadette Soubirous, seen kneeling, who saw 18 apparitions of the Virgin Mary in 1858. (Photograph by author.)

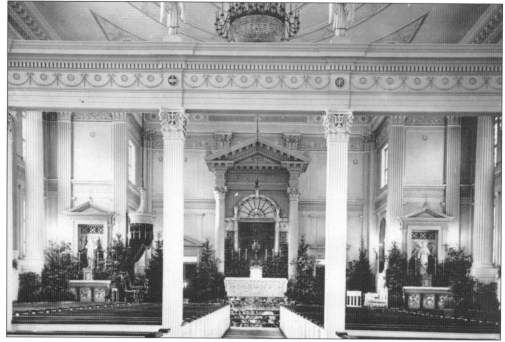

The interior of the Chapel of the Immaculate Conception is seen above decorated for Christmas in 1948. The photograph below shows the interior of the chapel as it looked in 2011. The chandelier in the center of the chapel is similar to one that hangs in the East Room of the White House. Cardinal Mundelein had to get an act of Congress to hang the chandelier, a gift from the Austrian government, in a public place. (Above, USML; below, photograph by author.)

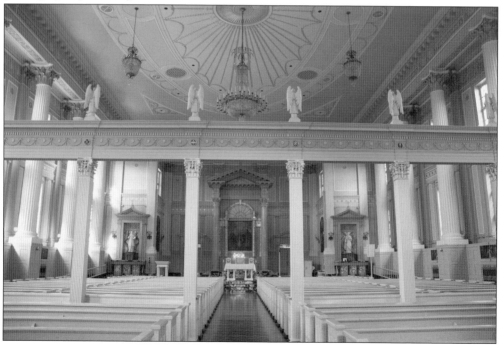

The statute of Pope Pius X was erected in 1953 near the auditorium, which can be seen in the background. The statue was the work of C. Pisi of Rome and sits on a stone pedestal sent from Barre, Vermont. The statue was the gift of Msgr. Victor Primeau, pastor of Our Lady of Grace Church in Chicago. (BARC.)

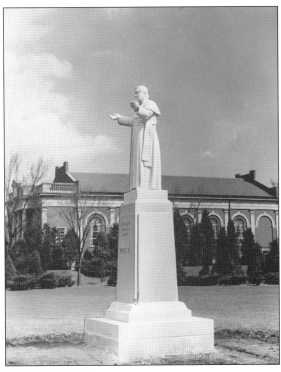

The Mundelein Seminary logo, as it looked in 1934, is seen here. The dark figure is the phoenix, representing the city of Chicago and its rise from the ashes of the Great Chicago Fire. Below is a lily, the sign of the Blessed Virgin, which rises through Lake Michigan waters with the sun, representing the Risen Christ. The shield contains red, white, and blue, indicating a person can be a loyal American and a faithful Catholic. (BARC.)

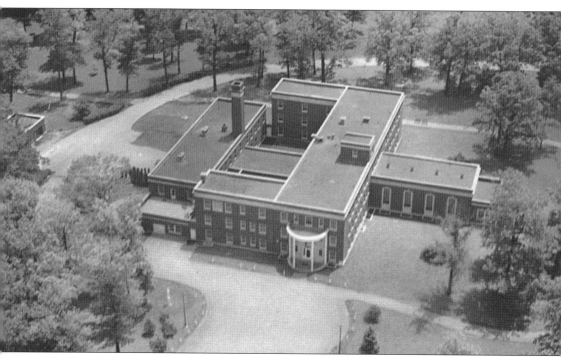

The Stritch Retreat House can be seen in this postcard. The Retreat House, which sits on property adjacent to the seminary, is run by the Archdiocese of Chicago and provides spiritual retreats for both lay Catholics and clergy. The building was dedicated in December 1951. (Author's collection.)

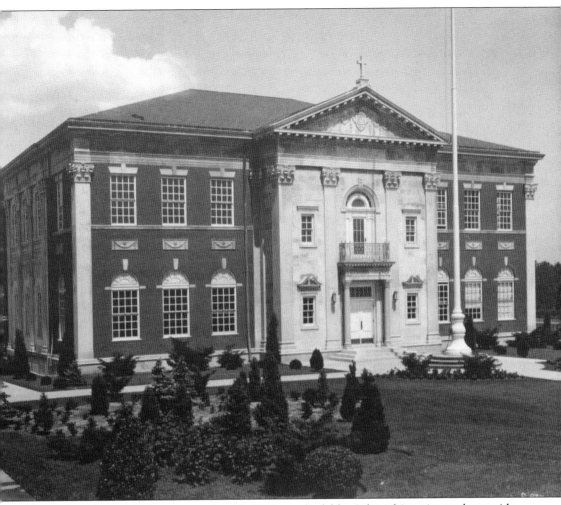

The Feehan Memorial Library, completed in 1929, may look like Colonial America on the outside, but it is Italian on the inside. Cardinal Mundelein attended the Propaganda Fide College in Rome, which was located in what had been the Barberini Palace. The design of the palace's library was used as a model for the interior of the Feehan Memorial Library. (USML.)

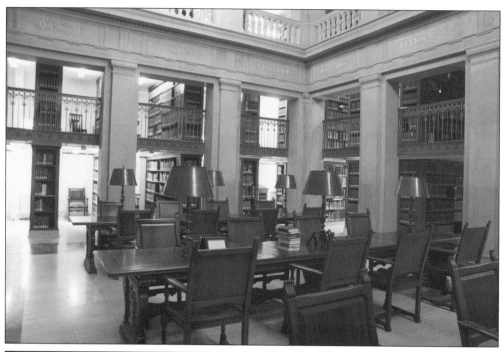

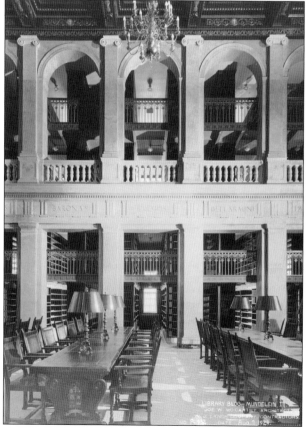

The interior of the Feehan Memorial Library looks strikingly the same in 2013 (above) as it did in 1929 (at left), with some exceptions. High-speed Internet is available, and resources around the world can be accessed through the library's extensive electronic databases. It also houses Cardinal Mundelein's collection of religious and Americana treasures. (Above, photograph by author; at left, BARC.)

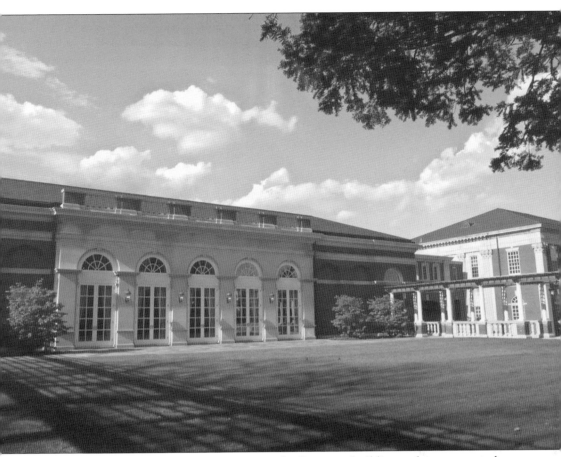

The McEssy Theological Resource Center was the first new building to be constructed on campus since 1934. The building, named for benefactors William and Lois McEssy, houses the library's collection on theology, scripture studies, and the history of the Christianity and the Roman Catholic Church. (USML.)

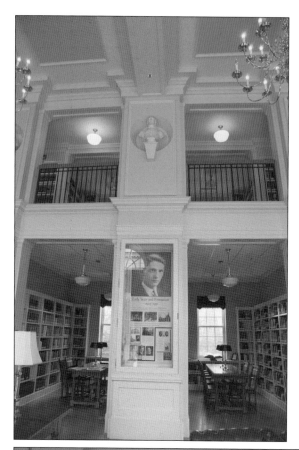

The new library addition, which opened in 2004, features a reading room (at left) with the busts of popes and church leaders created by sculptor Alexander Stoddart. Individual study spaces are available for seminarians (below), as are display cases. The bright reading room opens up to a terrace and garden that includes the Little Flower Cloister Garden, which was an additional gift from William McEssy in 2013. (Photographs by author.)

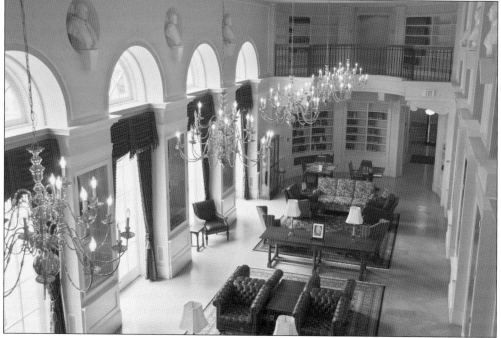

The Mundelein Seminary Class of 1943 gathered for a 50-year reunion on September 25, 1992. Of the 40 men who were ordained on May 1, 1943, only one had left the priesthood. Nearly all the men lived in the Chicago area, and all of them spent years working in parish ministry. Three of them became auxiliary bishops. (USML.)

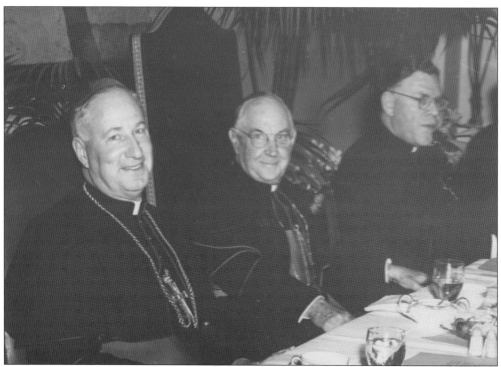

Although Cardinal Mundelein is the Episcopal leader most closely affiliated with the seminary, other church leaders played active roles. In the image above, Bishop William E. Cousins (left) is seen with Card. Samuel A. Stritch (center) and Msgr. Malachy Foley at a dinner in 1952. Cousins, who was among the first graduates of the seminary, was the archbishop of Milwaukee. Cardinal Stritch was archbishop of Chicago until his death in 1958. Foley was rector from 1945 to 1966. Below, Cardinal Stritch prays with members of the ordination class of 1958. (USML.)

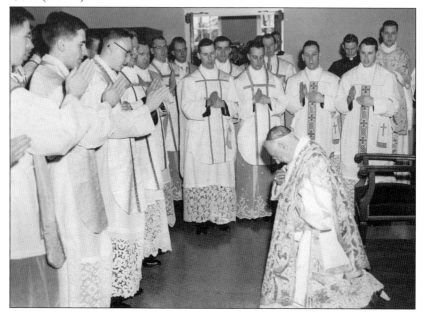

Above, Card. Albert G. Meyer poses a photograph with members of Mundelein Seminary faculty in 1959. Meyer was elevated to cardinal just a year after being named to head the Chicago Archdiocese. Meyer died in April 1965 and is buried at the seminary's cemetery. Below, thousands attended the funeral services on April 13, 1965. (USML.)

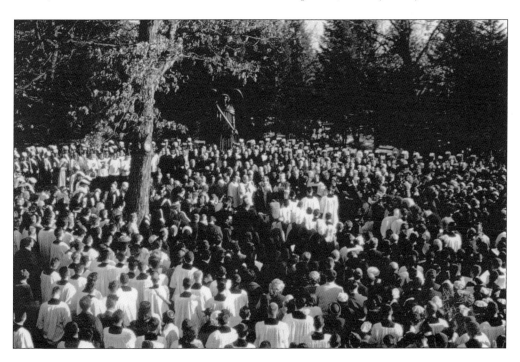

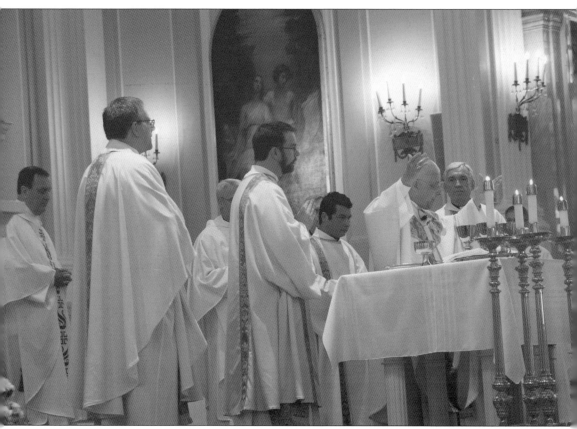

Card. Francis George, the current archbishop of Chicago, says Mass in the Chapel of the Immaculate Conception in 2012. Cardinal George has been the head of Chicago's 2.2 million Catholics since 1997. In the far left foreground is Fr. Robert Barron, noted author, speaker, and the 10th rector of Mundelein Seminary. Father Barron is also a graduate of the seminary. (Photograph by author.)

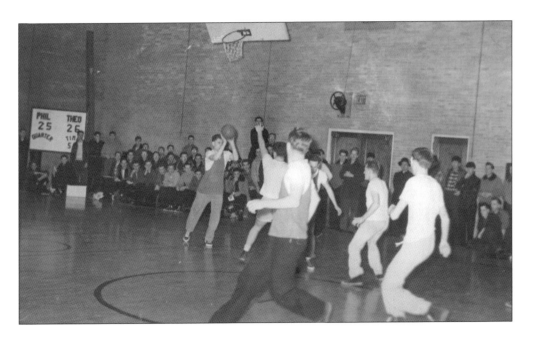

Above, a crowd gathers for a basketball game in 1950 between teams from theology and philosophy. Years later, seminarians are still playing basketball, but they play against other major seminaries in the annual Mundelein Seminary Shootout. In the photograph below, a player from Mundelein takes a shot against a player from Conception Seminary in Missouri in 2013 tournament play. (USML.)

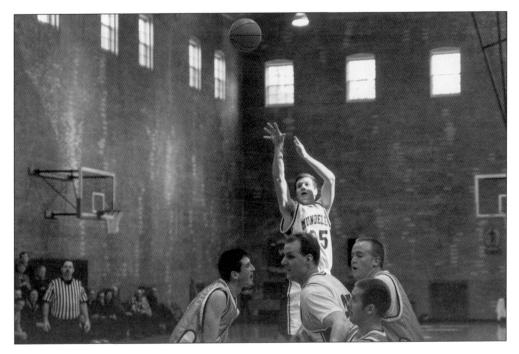

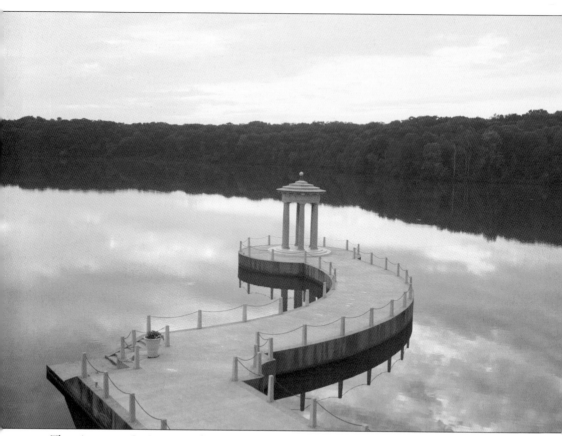

The view over St. Mary's Lake is always stunning, particularly from the belvedere and the piers. (Photograph by author.)